IMAGES
of America

THE WORCESTER
LUNCH CAR COMPANY

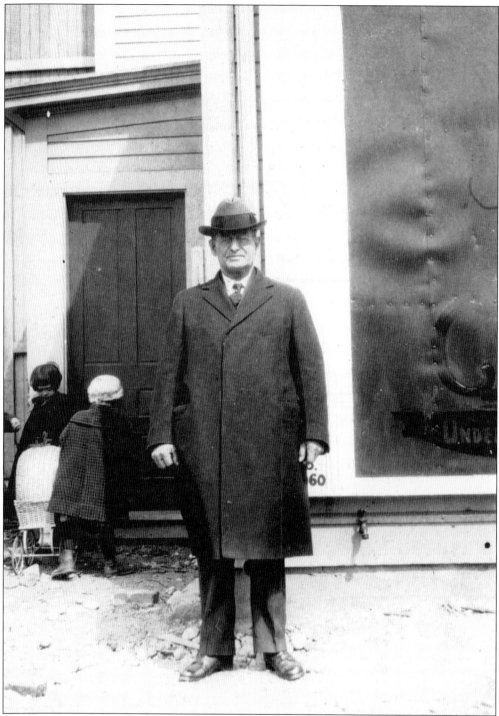

Charles P. Gemme was the man behind the Worcester Lunch Car Company. He devoted his life to the design and construction of diners. Gemme was responsible for every Worcester car built by the company at the intersection of Quinsigamond Avenue and Southbridge Street. He is shown here c. 1934, midway through his career.

IMAGES
of America

THE WORCESTER
LUNCH CAR COMPANY

Richard J. S. Gutman

ARCADIA
PUBLISHING

Published by Arcadia Publishing
Charleston SC, Chicago IL, Portsmouth NH, San Francisco CA

Printed in the United States of America

Library of Congress Catalog Card Number: 2004101854

For all general information contact Arcadia Publishing at:
Telephone 843-853-2070
Fax 843-853-0044
E-mail sales@arcadiapublishing.com
For customer service and orders:
Toll-Free 1-888-313-2665

Visit us on the Internet at www.arcadiapublishing.com

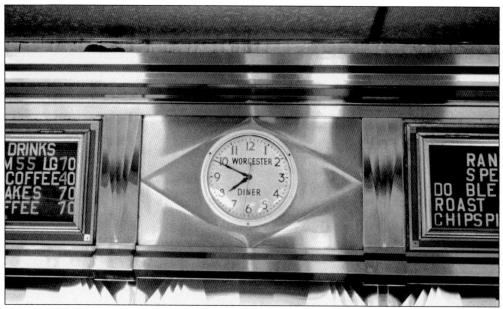

Every inch of a diner was designed to be both functional and ornamental. The centrally mounted clock (in the stainless steel hood above the counter) let the patrons know they were in a Worcester diner and how much time they had to finish their meals. This clock was in the Georgetown Diner (No. 849), built in 1955. It was located in Georgetown, Massachusetts. The diner is now in London, England (see pages 126–127).

CONTENTS

Acknowledgments 6

Introduction 7

1. Lunch Wagon Beginnings 9

2. Meals on Wheels 19

3. The Lunch Car Becomes a Diner 29

4. Wheeled Wonders 81

5. The Streamline Era 89

6. Worcester Stands Pat 101

7. The End and the Beginning 113

Index to Illustrations 128

ACKNOWLEDGMENTS

This book would not have been possible without the encouragement, enthusiasm, and assistance of my friends William D. Wallace and Robyn Christensen, at the Worcester Historical Museum. I am delighted to be able to publish for the first time some of the treasures for which they are the keepers.

For 30 years, I have searched for Worcester lunch cars with John Baeder. For almost that long, I have traded information with Larry Cultrera. Of all the diner owners out there (and countless ones have helped me along the way), Dave Waller is my best friend.

The following individuals provided photographs and information for this book. I extend grateful thanks to John Baeder, Dick Chaisson, Larry Cultrera, Randy Garbin, Arthur Goody, Paul Gray, David Guss, William F. Hanna, Charles H. King, Don LaPlante, Michael McArdell, Ruth Ann Penka, Peter Ames Richards, Stephen Spencer, Cathy Stanton, Neil Todd, Dave Waller, and Douglas A. Yorke Jr.

I would like to acknowledge the following institutions and the people who helped me and provided images: Robert Norcross, Adams Historical Society, Adams, Massachusetts; Cynthia Read-Miller and Jim Orr, Benson Ford Research Center at The Henry Ford, Dearborn, Michigan; Kathleen (Kit) Rawlins, Cambridge Historical Commission, Cambridge, Massachusetts; Alan F. Rumrill and Tom Haynes, Historical Society of Cheshire County, Keene, New Hampshire; Maureen K. Harper, National Heritage Museum, Lexington, Massachusetts; Jane M. Hennedy, Old Colony Historical Society, Taunton, Massachusetts; Merrill Smith and Nicole Rioles, Rotch Visual Collections, Massachusetts Institute of Technology (MIT), Cambridge, Massachusetts; and Mary Clark, Thomas Crane Public Library, Quincy, Massachusetts.

Unless otherwise noted, the images used in this book are from my collection.

Our family's tradition of lunch at Casey's Diner was reinstated as the book neared completion. We met for a final meal before our daughter Lucy printed the last pictures needed for the book.

Finally, although Kellie, my wife of three decades, tried very hard to take a diner sabbatical while I worked on this book, she did manage to scan every photograph and read every caption more than once. For this I am forever in her debt.

INTRODUCTION

In 1974, I met Charlie Gemme for the first and only time. He was 90 and I was 25. I figured he had a lifetime of stories and hoped he could tell me about the five decades he was in charge of the factory that built Worcester lunch cars in Worcester, Massachusetts. As I approached his house on Plantation Street, I knew I was at the right place. Flanking the ordinary front door was a pair of light fixtures expressly made for Worcester diners in the 1940s.

Charles P. Gemme, a French Canadian from Marieville, Quebec, was the foreman from 1910 until the demise of the company 51 years later. Nominally, he was vice president and superintendent. Actually, he was the company's main designer and had a hand in every diner they built.

In 1972, I moved to Boston. I had just graduated with a degree in architecture from Cornell University's College of Architecture, Art & Planning and was enamored with the diners constructed under the watchful eye of Gemme. Worcester-built diners were known for their fine craftsmanship and solid construction; many sported beautiful graphics in colorful porcelain enamel with the diner's name (for example, Miss Bellows Falls) emblazoned across the 30-foot façade.

To get my degree, I had done a thesis on diners and was continuing my research when I went to interview Charlie Gemme. Little did I know that 30 years later I would still be at it. Although ancient and frail, he aided me when he filled out a sheet of paper with names of dozens of Worcester diners, noting the legacy of his life's work with the phrase "original fast food!"

He brought me to his bedroom and from the top drawer of his dresser extracted souvenirs for me to take away. These included a large-format negative from 1940 of the Mayflower Diner (see page 92) outside the factory, ready to be trucked to its location in Quincy; a five- by seven-inch photograph, taken at the same time, of the diner's interior; and a cardboard note tag from the late 1920s (see page 46) that featured the company's standard model from that era.

He answered my questions and filled me with more. He left me with an intriguing statement: "Why, you couldn't go into a town in New England without seeing a Worcester lunch car!" It sent me on a search that certainly provided the spark for this book.

I set out to document as many as I could, searching via Charlie Gemme's original list (most were defunct), the Yellow Pages, and word of mouth. Diner owners and diner customers were my greatest source for the next place down the road.

This was when I first discovered the diner resources at the Worcester Historical Museum—a repository of more documents relating to the Worcester Lunch Car Company than anywhere else. I never knew that Charlie Gemme had notebooks and record books tucked away somewhere in his house. These were eventually given to the museum.

The Worcester Lunch Car and Carriage Manufacturing Company was the premier diner builder in New England from 1906 to 1961. They turned out a total of 651 diners, sending them all across New England with the occasional unit going as far as Michigan and Florida. The diners had serial numbers beginning with No. 200 and ending with No. 850. These numbers are noted throughout the book.

Many Worcester diners still dot the Northeast. Approximately 90 are currently in operation. Some surviving diners are listed on the National Register of Historic Places. One Worcester

diner has been permanently installed at the Henry Ford Museum, in Dearborn, Michigan, as the centerpiece of an exhibition, the Automobile in American Life (see pages 120–121).

Throughout its history, the Worcester Lunch Car and Carriage Manufacturing Company renovated diners for owners and traded old models for new models. These old cars were reconditioned and resold—a recycling method that saved an older, smaller diner that might prove perfect for a would-be operator who could not afford a new unit. As a result, some diners occupied as many as nine different sites during their years of service, while others have remained at their original locations.

Besides their unique architectural appearance, diners have enjoyed an important role in the communities where they are located. Diner customers always get the latest news served up with their food, and current events—from sports to politics—are always on the menu. When a small-town diner shuts down its operation, it can be a problem. In July 1943, the Whitney brothers, Richard and Robert, went off to war and closed the newly opened Whit's Diner, in Orange, Massachusetts (see page 124). In a 1948 article in the *Orange Enterprise and Journal*, a writer describes townsfolk who "not only missed the delectable edibles but they ran dry on social pleasantries. They definitely knew a war was on, and the loss of the diner service was one of the privations they had to put up with."

The popularity of diners grew after World War II, and the prosperity of the 1950s was a golden age for them. More companies popped up at that time, and this competition was the beginning of the end for the Worcester Lunch Car Company. The other builders, concentrated in the metropolitan New York and New Jersey areas, created ever larger diners to satisfy the growing demand for seats. Worcester, however, remained focused on the smaller units that would easily fit into the urban sites where they were generally located. When owners of Worcesters outgrew their diners in the postwar period, they were often convinced to upgrade to a larger, flashier model built by the competition.

The growth of chain restaurants in the 1950s also had an impact on diners. Fast food—the McDonald's way—was a novelty, and diners were old hat. With the aging of the ownership and leadership of the Worcester Lunch Car Company, production slowly ground to a halt. The last new diner was built in 1957, and the company's assets were sold at auction on May 23, 1961.

One

LUNCH WAGON
BEGINNINGS

The diner was not born in Worcester, but it was in Worcester where diner building became an industry. In 1884, Samuel Messer Jones was laid off from the Corliss Steam Engine Works in Providence, and he appropriated the lunch wagon concept that Walter Scott originated 12 years before. Jones moved to Worcester and took the idea with him, opening the first lunch cart there on October 20, 1884.

This precursor to the diner was open only at night after other restaurants had closed for the evening. It was in a prime location—Main Street at the corner of Front. These were key features to a successful business: the right hours and the right spot. However, all wagons at this time required customers to stand on the street, as they were large enough only for the proprietor, his supplies, and equipment.

Jones built the first lunch wagon that a customer could enter. During the fall of 1887, it made its debut at the New England Fair in Worcester. The accomplishments of Jones prompted others to enter the trade, and he decided to move on to Springfield, Massachusetts, two years later.

Charles H. Palmer bought all of the wagons in Jones's chain, except one that Jones took with him to open in Springfield. Palmer received the first patent given for a lunch wagon design. His success in manufacturing wagons led him to establish a factory in nearby Sterling Junction while keeping an office at 51 Salem Street in Worcester.

The lunch wagons of the 1880s were simple, small affairs, measuring 6 by 16 feet. The interior was divided into a "kitchen apartment" with enough room for the operator to store food and drinks and prepare and serve sandwiches, pies, and coffee—the simple offerings. The rest of the wagon was devoted to the customers. It was said that 20 patrons could stand inside, and on cold or stormy nights, they evidently did.

In 1888, 20-year-old Thomas H. Buckley built himself a lunch wagon and called it the Owl. As with many wagons of the time, such as the Twilight Café and the Star, its name was a play on the nocturnal hours the diners kept. While overseeing the operation of the Owl, opposite the Soldier's Monument in Worcester, Buckley began manufacturing a series of triumphant lunch wagon designs. The best-known model was the White House Café.

By 1898, Buckley had his wagons in 275 towns across the country. He roamed the countryside with an eye toward those places likely to support a wagon. If nobody would buy one, he would set one up himself under the direction of a capable, handpicked manager—possibly establishing the first nationwide chain. This is why he was called "the Original Lunch Wagon King." However, his ambition, and a bout of peritonitis, killed him at the age of 35 on December 1, 1903. And that is how the Worcester Lunch Car Company came into being.

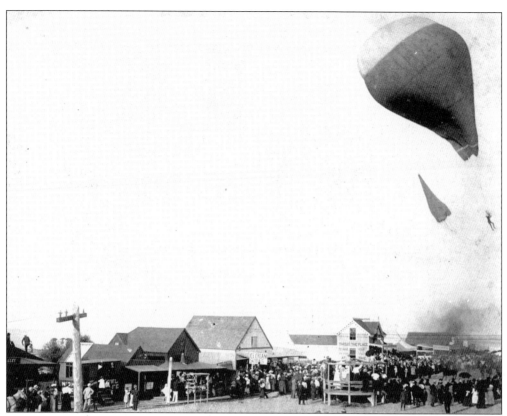

Customers in this Owl Café lunch wagon join the immense crowd captivated by the man precariously hanging from the hot-air balloon. This lunch wagon was built by Charles H. Palmer of Worcester. Its closed body style and few windows classify it as a very early model. This unidentified vacation spot is filled with tourists who could patronize the two photo galleries, the bowling alley, or the quick-lunch stand. This might be a great spot for business, as the only other visible culinary offerings are ice-cream sodas and peanuts. (Courtesy of Michael McArdell.)

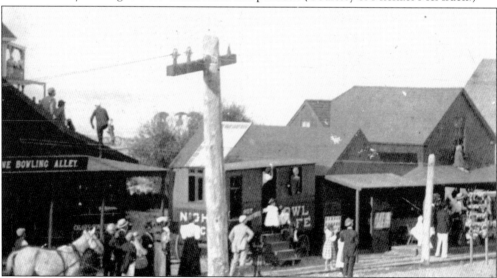

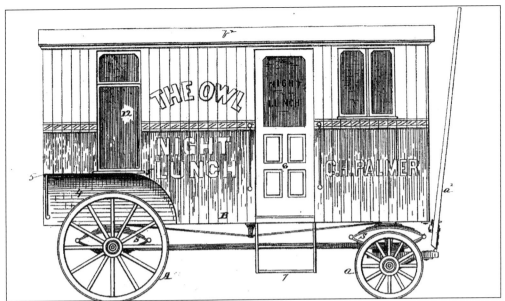

Palmer's patent, received on September 1, 1891, shows the same body style as the wagon on the opposite page. This wagon also has the same name and two-toned paint scheme. Takeout food was delivered by the attendant from the large, low window over the high rear wheel.

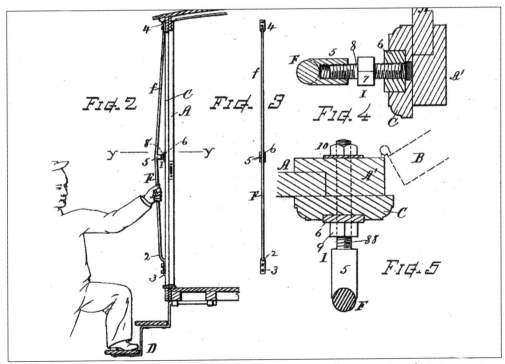

Early lunch wagon builders attempted to keep competition from copying their innovations by securing further design patents and continually making improvements upon their designs. Palmer invented a handle that would not only help customers hoist themselves up into the wagon but would also keep the flimsy walls plumb so the door would properly close and latch.

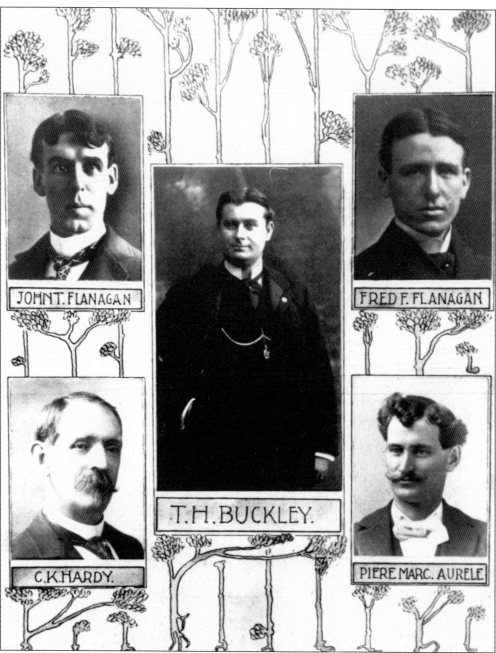

JOHN T. FLANAGAN

FRED F. FLANAGAN

T.H. BUCKLEY.

C.K. HARDY.

PIERE MARC. AURELE

The key personnel of the T. H. Buckley Lunch Wagon Manufacturing & Catering Company are pictured in this montage from the company's catalog. Tom Buckley, the "originator and leader in this line," was president and treasurer. The Flanagan brothers assisted him in managing the company. Hardy was the head painter and "general decorative artist." Aurele was the foreman of construction, presiding over wheelwrights, blacksmiths, carpenters, cabinetmakers, tinsmiths, and glass workers. C. K. Hardy was in charge of the murals painted on wagon exteriors, because of his reputation as a marine and landscape artist. He was also a notable portrait painter who showed his work in art galleries. (Courtesy of the Worcester Historical Museum.)

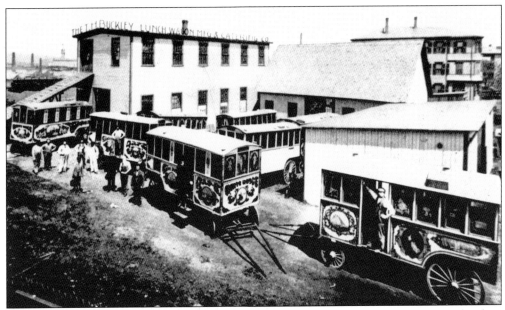

Wagons under various stages of construction spilled out of the Buckley factory's limited indoor space at 281 Grafton Street. In 1898, 55 craftsmen worked 14 hours a day to keep up with the orders for new wagons. In 10 years, they turned out nearly 650 units. Except for the painting, a wagon could be completed within 24 to 36 hours "in case of emergency." (Courtesy of the Worcester Historical Museum.)

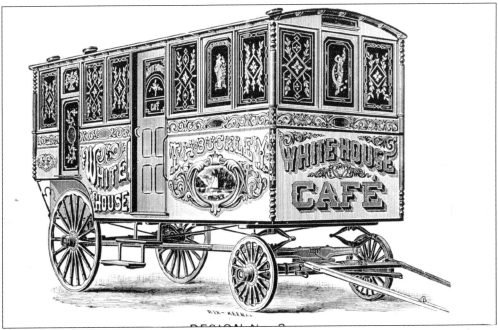

The Buckley-built White House Café was the finest of all mass-produced lunch wagons during the 1890s. "No less than 350 wagons" (the White House Café model) were built from its introduction in 1891 through 1898. The colored-glass windows included depictions of four goddesses: Music, Flowers, Day, and Night. (Courtesy of the Worcester Historical Museum.)

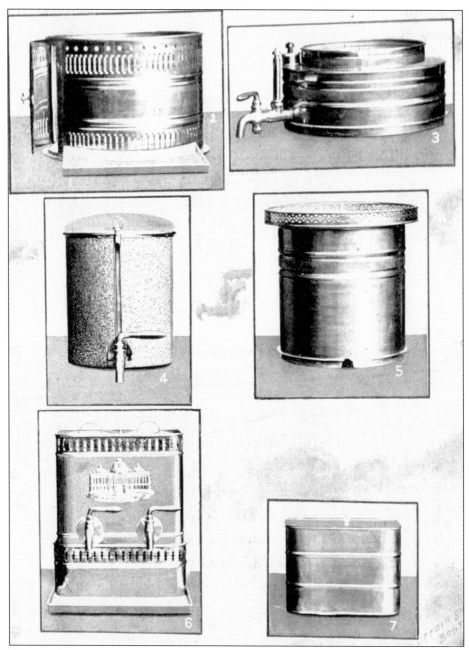

Buckley lunch wagons came completely equipped with various urns, dishes, and a sink, in addition to a refrigerator for storing meat, milk, and ice cream. This view from the catalog illustrates the coffee urn, separated into its various components. Nos. 1 and 2 show the drip pan and base. No. 3 is the hot water tank, holding four gallons for preparation of "cocoa, chocolate, beef-tea and coffee." No. 4 is the agate urn itself, lined with porcelain. No. 5 shows the burnished copper jacket, with space on top for holding mugs. No. 6 is the milk urn with two compartments—one for milk and the other for ice. No. 7 is the copper Frankfort urn. An urn of the same style is still in use today, steaming hot dog buns at Casey's Diner in Natick, Massachusetts (see page 56). (Courtesy of the Worcester Historical Museum.)

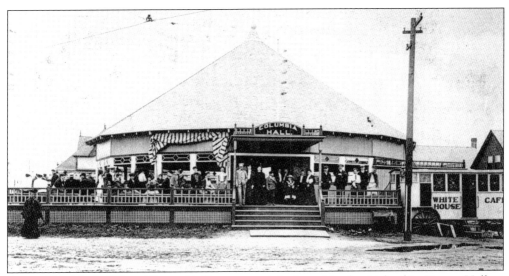

One of Buckley's White House Cafés was nestled alongside the Columbia Dance Hall at Salisbury Beach, Massachusetts, to feed the patrons who came for the 50¢ dances. This wagon is an older model with small windows at the kitchen end. Its original, elaborate paint job was not replicated when it needed repainting.

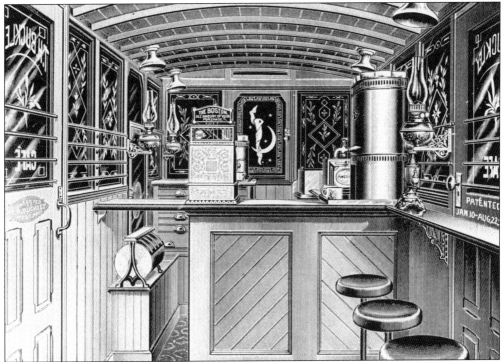

The all-wood, glass, nickel, and copper interior of this wagon shows a door on each side, although the right-hand exit appears blocked by the eating shelf and stools. The serving counter was dominated by a huge coffee urn and formidable cash register. Prominent by the hand-out window was a roller with manila paper for orders to go. Lighting was provided by kerosene lamps with smoke bells to carry away the smoke. (Courtesy of the Worcester Historical Museum.)

If you were hungry while strolling along Old Orchard Beach, Maine, the food options were limited to popcorn or the offerings of the Quick Lunch Café. In this undated photograph, two men have arrived by bicycle at the lunch wagon, perhaps having just had their faces put on a button photographically. (Courtesy of Michael McArdell.)

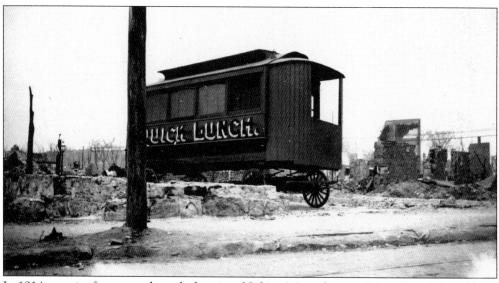

In 1914, a major fire swept through the city of Salem, Massachusetts. More than 400 buildings were destroyed and 3,500 families left destitute. The desolation can be seen in this snapshot of a bleak, empty landscape. A homemade lunch wagon was wheeled in to provide food for the homeless and for people working in the aftermath of the disaster.

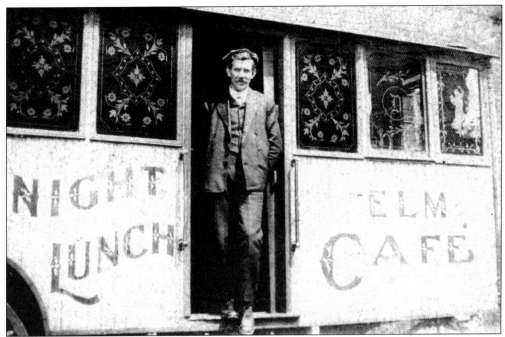

In these two unidentified photographs, the lunch wagon proprietors pose proudly at the entrances to their carts. Above, in a snapshot typical of the genre, the business is named the Elm Café and is also identified as a "Night Lunch." Below is the White House Café, located in Worcester. The wagon was nearly permanently installed on a slip of property appropriated from the street, with a board sidewalk and sturdy-looking steps. The running gear all remained at the front of the wagon, just in case a fast getaway was required. (Below, courtesy of the Worcester Historical Museum.)

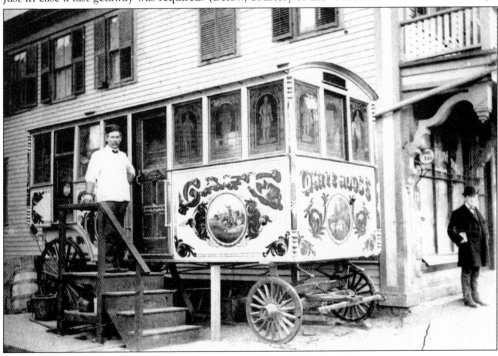

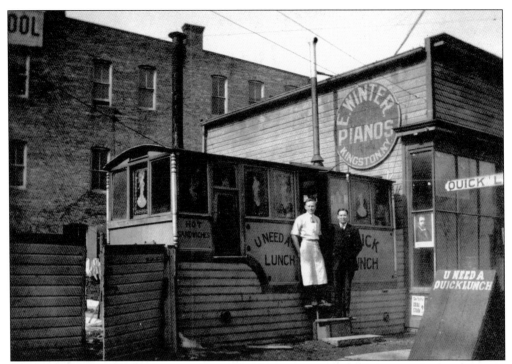

By the beginning of the 20th century, many lunch wagon owners had given up the use of horses. Wheels were still in place but were boxed in with wood, which gave a greater appearance of stability. Converse to this image was the continued use of flimsy temporary steps. With a permanent setup, rent would be required, but permanence also offered the potential for gas, water, and electricity. The U-Need-A Quick Lunch was located in Kingston, New York, in a lot adjacent to the E. Winter piano emporium. The White House Café was at the intersection of Mechanic and Commercial Streets in Worcester. (Above, courtesy of John Baeder; below, courtesy of the Worcester Historical Museum.)

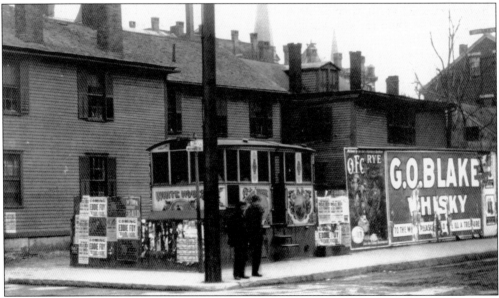

Two

MEALS ON WHEELS

Around the beginning of the 20th century, Worcester was a city of lunch wagons. There were no fewer than 14 men guiding their horses through the streets at dusk, parking their wagons at designated spots and serving food until the wee hours. During this time, the opportunity to enter a growing business dawned on one local entrepreneur who had a vision for the future.

Philip H. Duprey was an established insurance and real-estate agent when he formed the Worcester Lunch Car and Carriage Manufacturing Company in December 1906. As president, Duprey made Granville M. Stoddard the treasurer. Duprey bought out the newly established partnership of Wilfred H. Barriere and Sterns A. Haynes. Barriere had been a carpenter for Thomas H. Buckley from 1899 to 1905, until he joined Haynes, a blacksmith, in the new venture.

A month later, another former Buckley carpenter, Charles P. Gemme, was hired. Incorporating some of Buckley's former employees, Worcester occasionally advertised itself as the successor to the T. H. Buckley Company. The small organization was initially composed of a half-dozen woodworkers, blacksmiths, and painters who worked off-and-on as required. Their first wagon, called the American Eagle Café, was completed in early 1907. It was given the serial number 200.

The first Worcester lunch car operated on Myrtle Street in Worcester behind the post office. Its exterior was elaborately painted in the tradition of Buckley's most flamboyant White House Cafés. Fancy block lettering, florid scrolling, and intricate pinstriping covered the body of the wagon, which also featured landscapes and hunting scenes in the style of the Dutch Old Masters. Colored-glass windows were executed in varied designs.

The first design was reminiscent of the Buckley offerings in many ways, but the wagon sat on two sets of low wheels, rather than the high rear wheels previously used. This meant more room on the inside where the kitchen still occupied the rear end of the wagon. Gas lamps provided lighting. The entire interior was finished in highly varnished natural wood, and the ceiling was decorated with gold-leaf striping and fleurs-de-lis. A few wooden-topped stools were provided along the eating shelf.

By the time they had built their ninth wagon—the Buffet Lunch, owned by Peter Neebonne— the size was half again as long, with a center entrance and another door on the end. The painting scheme was considerably less decorative, and the interior layout was changed. The new scheme placed the kitchen along the length of the car, with a long serving and eating counter, and a row of stools running down the middle.

On May 23, 1908, Charles P. Gemme was put in charge of the factory. He had all his brothers working there at one time or another. His older brother Henry was the first to come; then came Adelard, a carpenter, and Paul, a painter. Wilfred Gemme began on April 22, 1912, when he left school. That week he earned $7.50 for 54 hours of work (14¢ an hour).

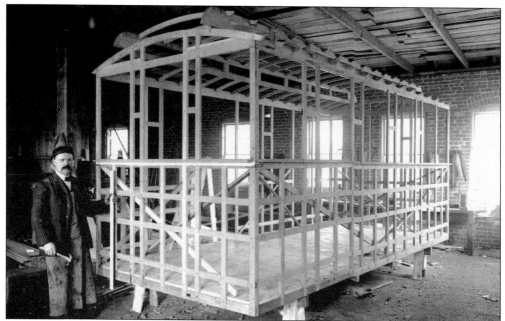

Wilfred H. Barriere, T. H. Buckley's carpentry foreman, was hired on December 22, 1906, to run the Worcester Lunch Car and Carriage Manufacturing Company. He is shown here completing the framing of a lunch car inside the factory. He ran the company for a year and a half at $25 per week, supervising the carpenters, blacksmiths, and painters. (Photograph by E. B. Luce.)

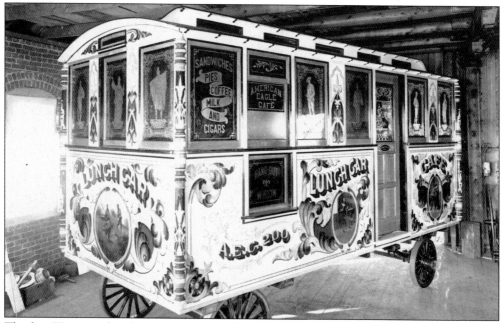

The first Worcester lunch car, the American Eagle Café, had its serial number (200) painted on the exterior. It was photographed before it ever left the plant. The design incorporated a new roofline: a barrel shape when viewed from the end, with a monitor, or railroad-style clerestory running the length. (Photograph by E. B. Luce.)

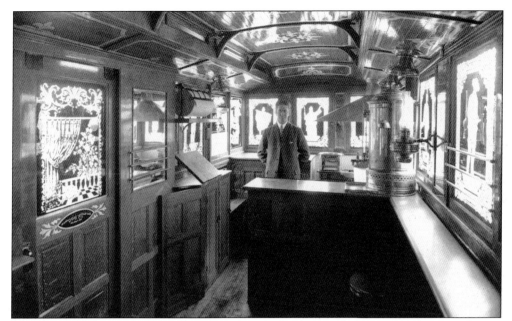

An unidentified man, possibly a buyer, poses in the kitchen of the first unit. A striking feature of the floodlit wagon's interior was the effect of the flash-glass windows, made by fusing colored glass to clear glass. Designs were etched into the color with acid, the most intricate being on the front door: a representation of a drawn curtain revealing a courtyard or balcony. (Photograph by E. B. Luce.)

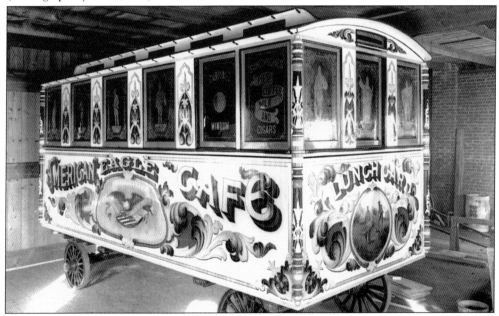

Shown in this image is No. 200, wheeled around to document the back of the car. This lunch car was intended to operate in the street. It has a carriage window where takeout food could be handed over from the attendant to patrons who rode up to the early "drive-through" window. The limited menu of sandwiches, pies, coffee, milk, and cigars was etched into the window alongside. (Photograph by E. B. Luce.)

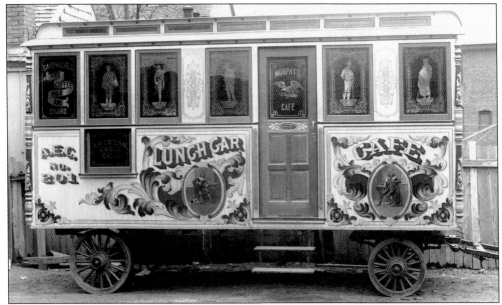

Murphy's Café was the next car built and hauled outside for a photograph. It was identical in size to its predecessor and had only minor changes in the decorative paint scheme on the entrance façade, such as the placement of the serial number. The artist has reprised his Dutch Old Masters–style paintings but has added a dog to the one on the left. (Photograph by E. B. Luce.)

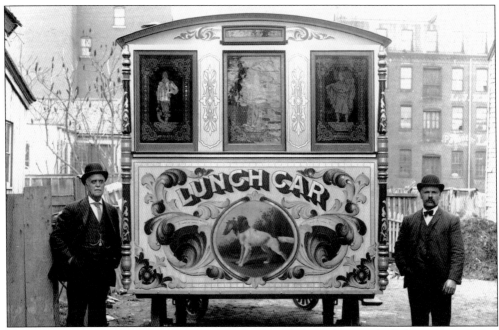

Treasurer Granville M. Stoddard (left) and president Philip H. Duprey (right) seem gratified to pose by the kitchen end of Murphy's Café (No. 201). The body of the car is embellished with a wonderful hunting scene, surrounded by the fancy scrolling and lettering that covers all the wood sheathing and corner posts. (Photograph by E. B. Luce.)

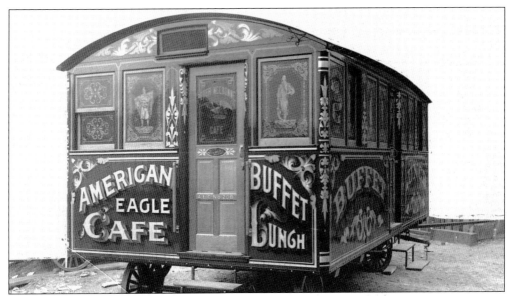

The Buffet Lunch (No. 208) represented a new, much longer and more symmetrical design. The kitchen ran the length of the diner in what was to become the traditional layout. A new simplified roofline completed the overall look, along with a paint job that eliminated the landscapes and portraits. This picture was taken in front of the plant. Presumably, this image was used in an advertisement; the background was painted out on the cracked glass negative. (Photograph by E. B. Luce.)

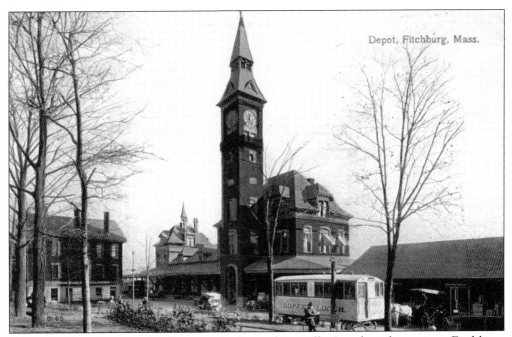

Not long after the original, Worcester built another Buffet Lunch and sent it to Fitchburg, Massachusetts. It remained on its wheels, operating in front of the passenger station for the Boston & Maine Railroad by the lower common at the junction of Main and Water Streets. On the back of this undated postcard is the curious booster slogan "Force Fitchburg Forward."

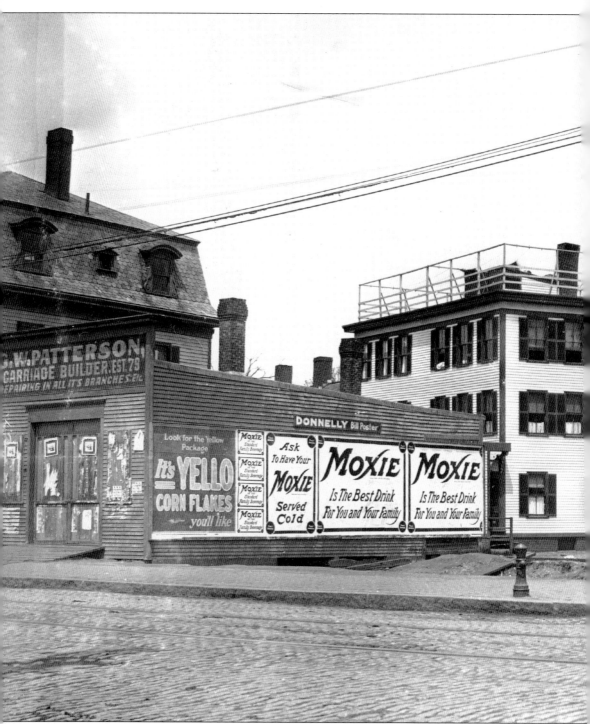

The Bostonian Café was paradoxically located in Cambridge, Massachusetts, at the bleak intersection of Main Street and Broadway, known as Kendall Square. In this May 6, 1909, photograph, the elaborate decoration on the lunch car's façade is overshadowed by the bold billboards advertising Moxie. If the diner owner did not have Moxie on the menu, that was a

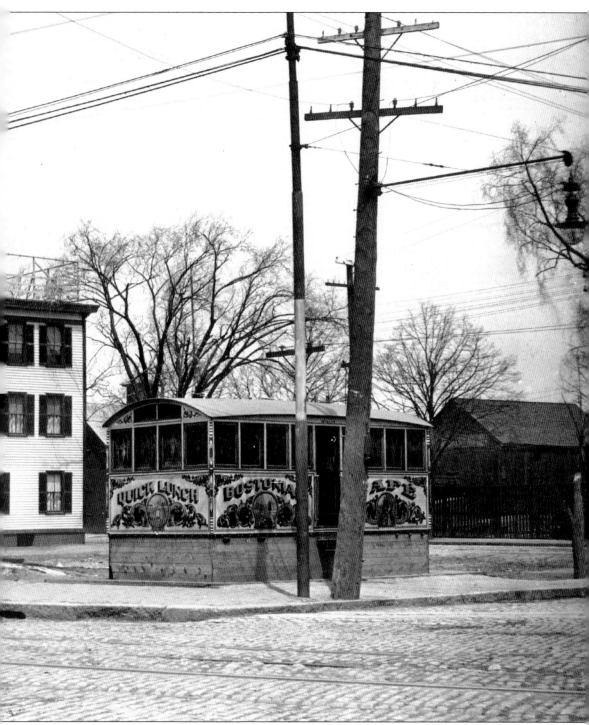

big mistake. The serial number of this car is not known, but given the paint job and roof styling, it was most likely built during the transition from the earliest wagons to the ones with the long counter running the length of the car. (Courtesy of the Boston Elevated Railway Collection, Cambridge Historical Commission.)

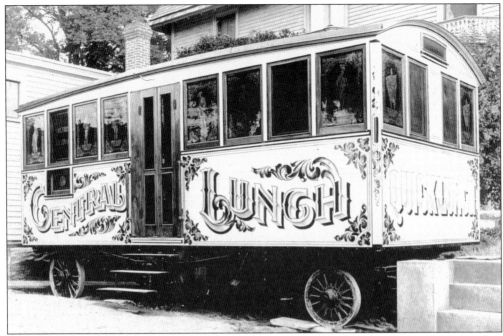

The Central Lunch was known as a "front-yard location." The owner relinquished a sliver of his property, paid no additional rent, and used the home kitchen for extra prep space. This diner was installed in Millbury, Massachusetts, in 1910. The interior view shows the long wooden counter. As lunch cars grew longer, the size of the kitchen increased proportionally. In 1930, this diner was replaced by Worcester Lunch Car No. 673, which is still in operation.

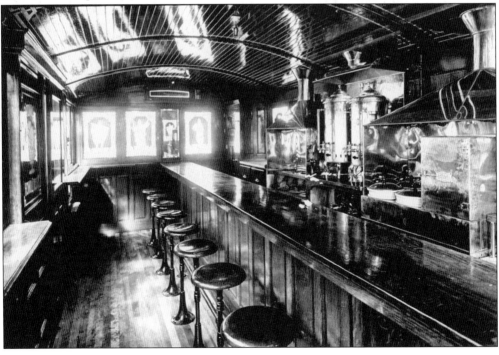

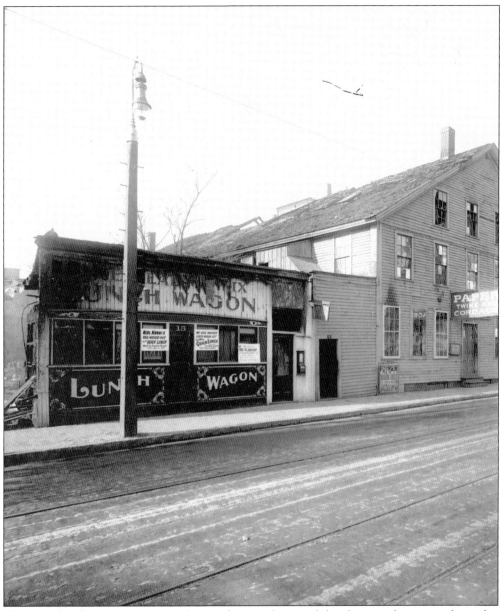

When Cornellius Mannix's Quick Lunch was destroyed by fire, as documented in this unidentified photograph taken in Worcester, he could be sure that representatives from the Worcester company would promptly pay him a visit, hoping to build Mannix another. Neal Mannix began business by 1905, and when this fire occurred, he was also operating the Model Quick Lunch next to the Franklin Theatre. Posted signs directed his customers to that wagon, which was open day and night. (Photograph by E. B. Luce.)

Serving the World

with

Worcester Dining Cars

Worcester Lunch Car Company

Worcester, Mass.

Factory: 2-8 Quinsigamond Avenue
Uptown Offices: Duprey Bldg., 16 Norwich St.

Philip H. Duprey, *President*
Irving M. Stoddard, *Treasurer*

SUPPLEMENT TO GENERAL CATALOG

In 1917, the Worcester Lunch Car Company moved from its cramped quarters at 69 Franklin Street to a new plant at the corner of Quinsigamond Avenue and Southbridge Street. Inside, there was room to work on three to six diners at a time, depending upon their size. The company's billhead was still sporting a woodcut of their first diner, No. 200. Although they proclaimed they were "Builders of Modern Up-to-Date Lunch Cars," they still advertised wagon building and repairing, and continued to do so as late as 1929.

Three

THE LUNCH CAR BECOMES A DINER

In the mid-1920s, the lunch car, striving for greater respectability, became known as a dining car. Quickly the appellation was shortened to "diner." Back in the previous century, when the wagons operated only at night, the term "night lunch wagon" made sense. Now, some cars were open 24 hours, serving breakfast, lunch, and dinner; the allusion to railway dining was appropriate because of the similar build (long and narrow), and it was hoped that the promise of fine cuisine might boost business.

The diners continued to be built on wheels and often kept their wheels after they were permanently installed. This was mandated in the city of Boston, as fire officials evidently thought it would be safer (and easier) to cart off a burning diner than to extinguish the flames where it stood.

When a customer slid open the entrance door of a 1920s Worcester diner, he (usually men patronized diners) was immediately struck by the long counter built of pink Tennessee marble. The walls and floor were surfaced in white tile. The plated metal coffee urns and other equipment sat beneath a shining hood of German silver, a precursor to stainless steel. The oak woodwork was highly varnished.

These materials and finishes combined to create an inviting appearance. A 1925 catalog stated, "Worcester Dining Cars are attractive, clean, and sanitary. People like to eat in them. They are well lighted. There are no dark corners where the dirt can lurk."

They advertised a feature exclusive to their diners. The lower halves of the car's windows were frosted, and the upper halves clear. This gave customers a clear view of the street, while passersby could see in without being able to identify the people inside.

Worcester offered a wide variety of sizes to fit the prospective owner's budget and site. The 10-seat model was a perennial favorite, because it could nestle in almost anywhere. Whenever there was an order for a really big diner, the company was sure to contact the newspaper. The East Coast Diner, bound for West Palm Beach, Florida, in February 1926, took three trucks to haul it to the freight yard, where it was loaded onto a flatcar and shipped by rail. At 44 feet long and 10 feet wide, it was the largest "cart" ever manufactured in the city. It was one of six diners sent to the Sunshine State at that time.

The demand for Worcester-made diners had the company running constant overtime shifts for at least a two-year period. A slower but steady output continued through the 1929 stock market crash and into the 1930s. Seventeen diners were built in 1931, 12 in 1932, and 15 in 1933. Workers were then laid off and brought back in only when needed.

Although diners were sometimes called depression-proof businesses because everyone still needed to eat, the company built only three new diners from November 1933 to May 1936. They did not recover fully until 1939, when orders came in for 14 new units.

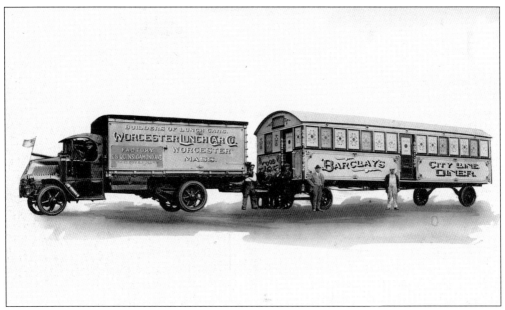

For more than four decades, Arthur H. LaFleur was the trucker and rigger who moved Worcester diners from the factory to their sites. He is shown here in 1925 at the wheel of his chain-driven Mack truck, about to haul off Barclay's City Line Diner (No. 488), while some of his crew pose with workmen from the plant. Supposedly, LaFleur insisted that the painting crew of the Worcester Lunch Car Company keep the lettering on his truck looking fresh and new at no charge. Another shot of the gang is shown in the tattered snapshot (lower right). LaFleur is standing third from right, identifiable by his distinctive nose.

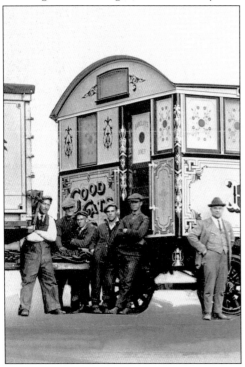
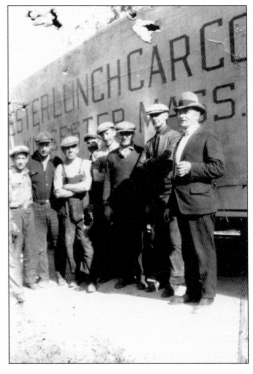

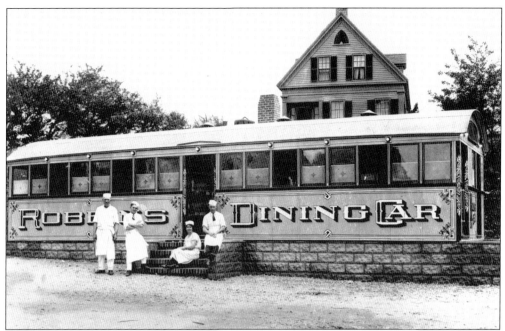

Robbins Dining Car was a huge unit. It was located on the main road along the beach, sometimes called the Boulevard, and was big enough to handle the beach crowds at nearby Nantasket, Massachusetts. The diner was owned by C. A. Robbins, who had all his employees put on clean aprons before this photograph was taken. The picture was used in the Worcester Lunch Car Company's 1925 catalog. The matchbook used a stock diner image that did not represent the design of the actual diner. One wonders if they really did have "the Best Ham & Eggs in America."

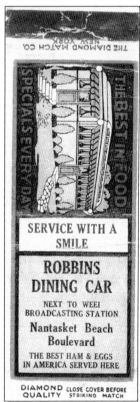

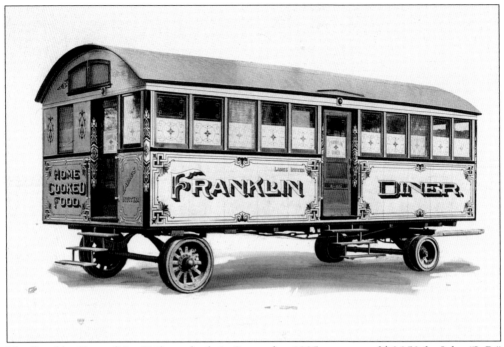

The Franklin Diner (No. 511) was built in September 1925 at a cost of $6,250 for John "J. B." Morin. It was 12 feet wide and 26 feet long, with a double row of stools. The signage includes an invitation for women to come inside for the "Home Cooked Food." Worcester's new half-frosted, half-clear glass windows are seen here. J. B.'s sons and grandsons followed him in the food service business. This diner stood for more than 60 years at its original location on Mill Street in Attleboro, Massachusetts. The photograph below shows its appearance in July 1974. (Below, courtesy of John Baeder.)

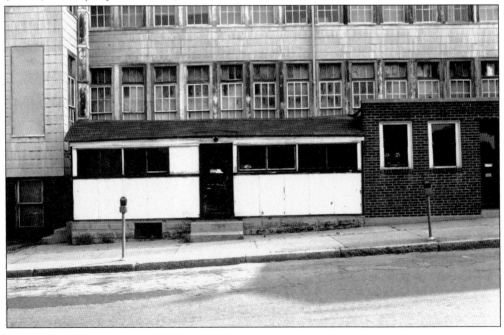

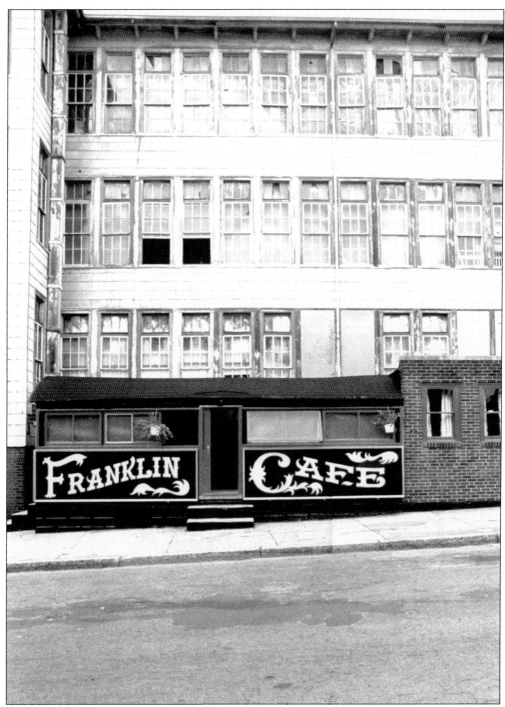

J. B. Morin's grandsons, Billy and Rusty Morin, revived the diner in the late 1970s by gussying it up. They renamed this 1925 diner the Franklin Café, after the very first lunch car that opened on the site in 1911. Despite their good efforts, they were not successful with the diner. The business was sold, and the diner was demolished in November 1986 to provide more office space for the factory behind it.

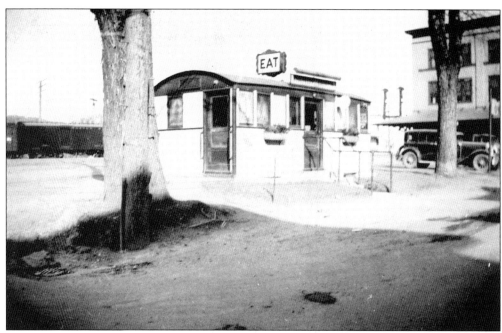

The Dandy Diner was a 10-stooler, the most popular size offered by the Worcester Lunch Car Company in the 1920s. It sold for $4,550. It was located in Railroad Square, Woodsville, New Hampshire, and some rolling stock is visible in this photograph. The unidentified cook happily scrambles some eggs. The diner is long gone, but the wooden sign, "Dandy Diner," lived on.

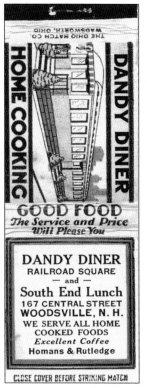

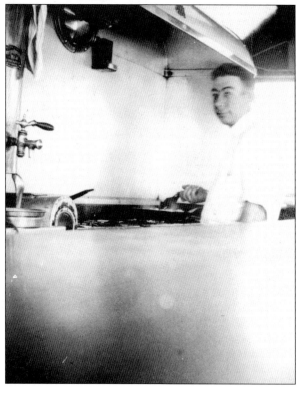

Because frankfurters were a staple, one generic term for lunch carts was "dog wagons," even without a dog on the stoop. This 10-stooler was located in York Beach, Maine, and last operated under the name of Hodgin's Diner (No. 272). Boarded up for years, it was in danger of collapse when recognized as one of the earliest Worcesters in existence. Many parts were salvaged by Dave Waller, owner of the Apple Tree Diner (see pages 122–123).

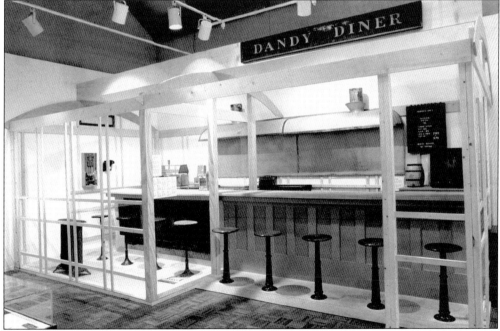

The Dandy Diner sign—along with stools, counter paneling, and the hood from Hodgin's Diner—was displayed in the 1995 exhibit entitled American Diner Then and Now, at the Museum of Our National Heritage, in Lexington, Massachusetts. The museum installed a diner skeleton that was inspired by the photograph of Wilfred Barriere (see page 20). (Courtesy of the National Heritage Museum, Lexington; photograph by Bill Wasserman.)

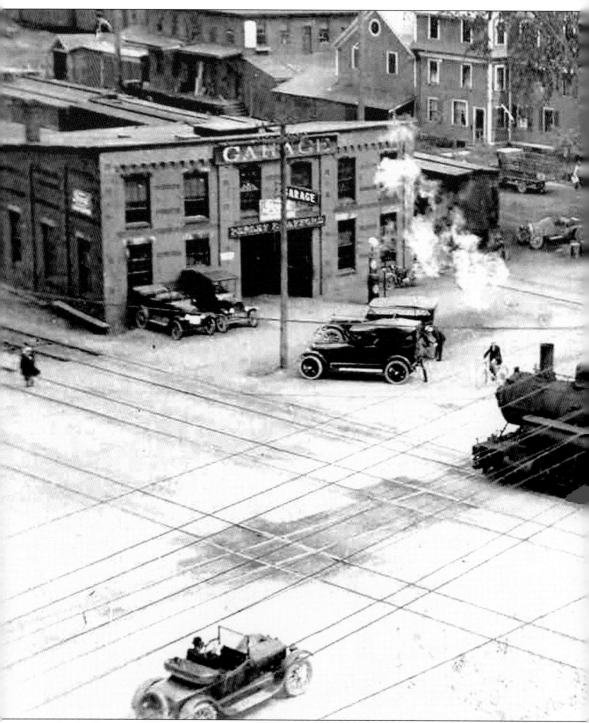

This bird's-eye view from the 1920s shows Main Street in Keene, New Hampshire. Keene's first diner, Dee's Lunch Wagon, is visible behind the railroad crossing sign beyond the locomotive, although partly hidden by foliage. Edward P. Dee opened his diner at 92 Main Street in 1921 on a plot of open land where Cypress Street hit Main. Johnnie's Diner followed Dee's Lunch on

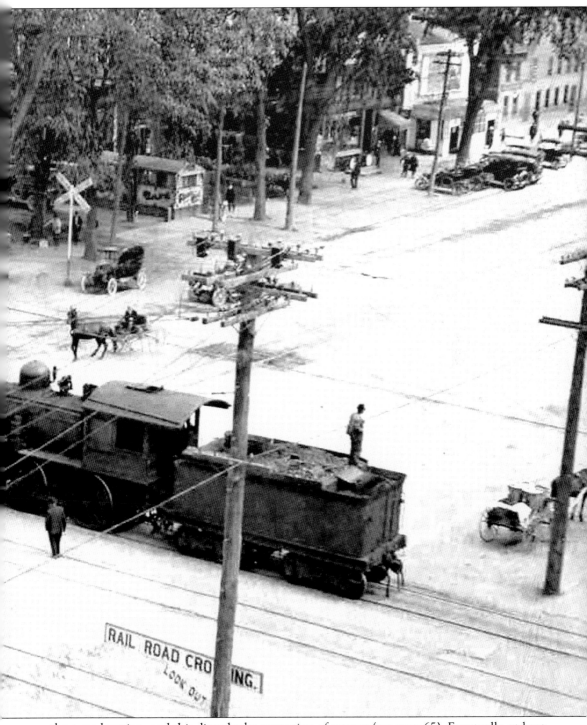

RAIL ROAD CRO ING.
LOOK OUT

the same location, and this diner had a succession of owners (see page 65). Eventually, at least eight more diners operated in Keene. Lindy's is the only one left and was built by Paramount Diners, not Worcester. (Courtesy of the Historical Society of Cheshire County.)

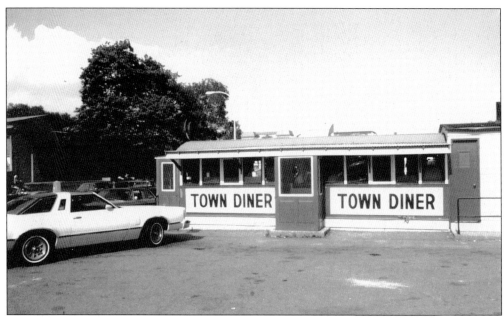

When the above photograph was taken in April 1979, Worcester Lunch Car No. 475 was trading as the Town Diner at 290 Main Street in Hudson, Massachusetts. In April 1981, the author gave a lecture about diners, and Jack Mullahy, of Hudson, was in the audience. Inspired by what he saw and heard at the library, Mullahy and Paula Frechette purchased the Town Diner and restored it. They renamed it the Sidetrack Café, and it was opened for business within a few months. The pair ran the diner until 1983. In 1994, it was moved to Alpena, Michigan, but never opened again for business.

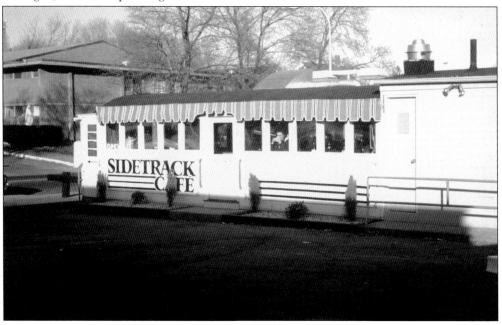

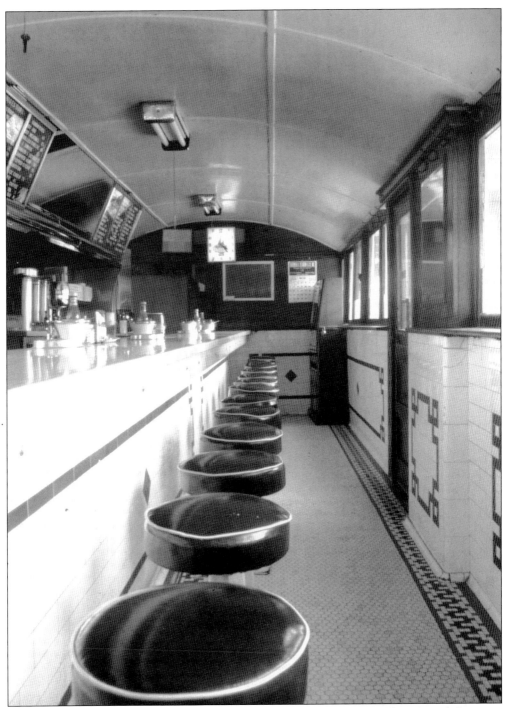

This view from 1979 shows the unrestored interior of the Town Diner. The 14-stool diner was built in 1925. Other than the painted ceiling and fluorescent light fixtures, it retained its original furnishings, including all tile work, porcelain enamel stools, and German silver hood. The door along the front wall slid open, and it slipped into the pocket where the tile juts out slightly into the diner. This image can be compared to the interior view on the following page.

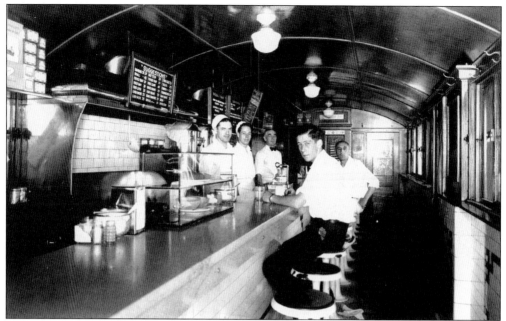

Pictured in Art's Filling Station (No. 549) are, from left to right, Loyal Spaulding (short-order cook), Harold Huff (counterman), and J. Edward Parks (co-owner) in this photograph from 1930. Parks's brother-in-law Arthur W. McKee was his partner. The diner was located at 176 Main Street in Waterville, Maine, and opened on October 23, 1926. The menu's "suggestions" ranged from baked beans at 15¢ to a small steak for 45¢.

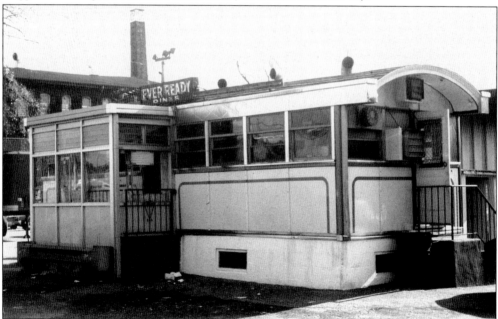

The Ever Ready Diner, shown in this image from October 1975 at its Admiral Street location in Providence, Rhode Island, is the same diner as Art's Filling Station. It moved from Maine to Massachusetts and then went to New Hampshire, back to Massachusetts, and finally to Providence. Along the way, it had two renovations at the Worcester Lunch Car Company factory.

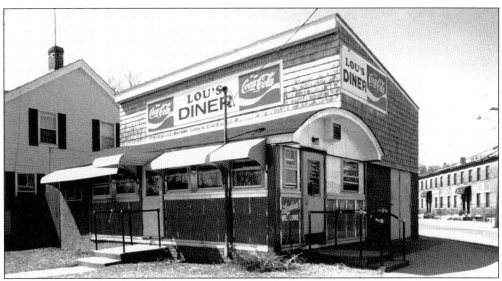

Lou's Diner (No. 638), at 100 Chestnut Street in Clinton, Massachusetts, dates from 1929. This photograph shows it sporting a bright red porcelain enamel façade that had been installed by workers from the Worcester factory in the 1950s. The exterior upgrade included new windows. Inside, a new stainless steel hood covers the original one made of Monel metal, a precursor to stainless.

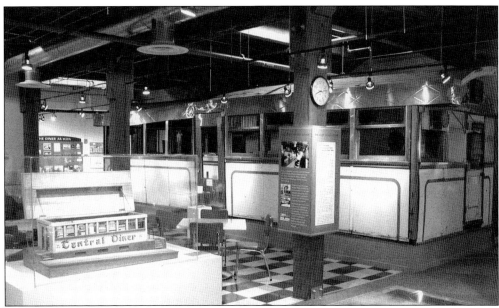

The Ever Ready is part of an exhibition entitled Diners: Still Cookin' in the 21st Century, at the Culinary Archives & Museum at Johnson & Wales University, in Providence. It has been idle for 15 years and awaits restoration. Tom Conley and Roger Godin brought it to Providence in 1958, when it replaced an earlier Ever Ready Diner that had worn out. In 1989, Morris Nathanson and Bud Frank donated it to the museum. (Courtesy of Stephen Spencer.)

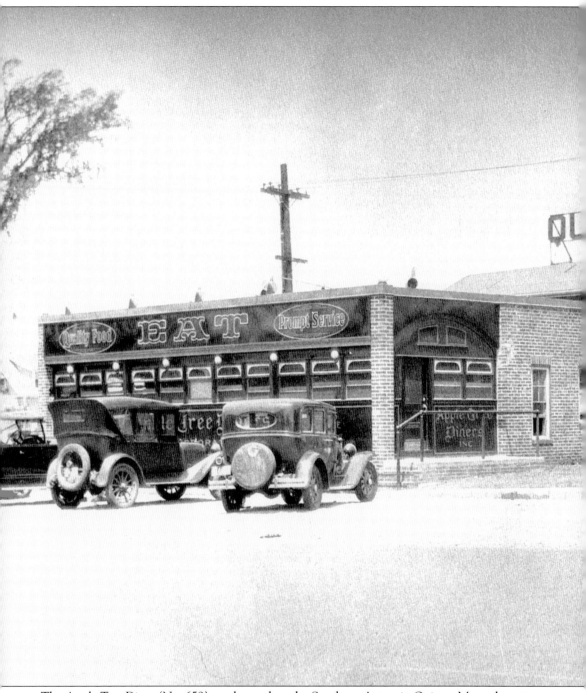

The Apple Tree Diner (No. 659) was located on the Southern Artery in Quincy, Massachusetts, and was operated by Richard Russell Sr. when this photograph was taken on June 3, 1930. In a highly unusual installation, the original owner encased the building in a brick structure that boxed off the roof, although the barrel is still visible on the end. Given the full parking lot, it

appears to have been a popular place. The diner later moved to Route 1 in Dedham, where it last operated under the name Midway. Ironically, the Jenks family, who ran the Midway, lived across from another diner called the Apple Tree, on Washington Street in Dedham (see page 122). (Courtesy of the Thomas Crane Public Library.)

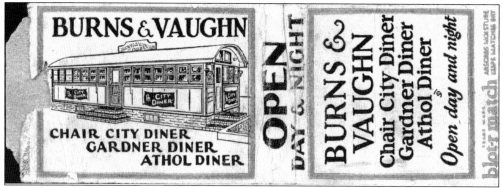

Matchbooks were good diner giveaways. Often, the matchbook company salesperson would proffer a stock diner image, but this one accurately depicts the actual building. In 1909, Frank M. Burns opened the first diner in Gardner, Massachusetts. Later, Burns and his partner Vaughn co-owned a small chain of diners in the area. This matchbook depicts the Chair City Diner, named after Gardner's most prominent product.

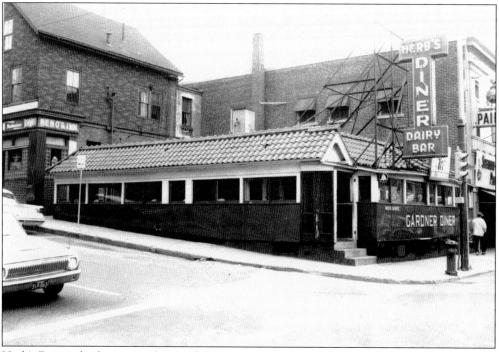

Herb's Diner, also known as the Gardner Diner, was located at 51 Parker Street in Gardner. It was originally owned by Frank M. Burns. He operated the diner shown here from (as early as) 1943 until 1956, when Ray Beaulieu ran it for four years as Ray's Diner. It was demolished in the 1970s, and the Volney Howe Park was created on the site.

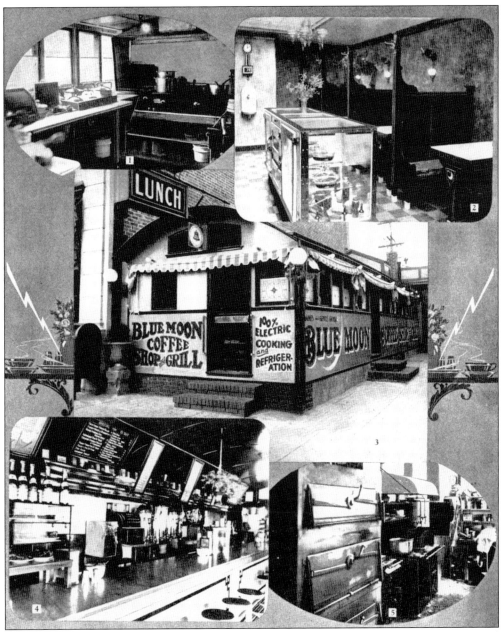

In 1929, Thomas J. Kiosses and Joseph D. Perrault opened the Blue Moon Coffee Shop and Grill at 102 Main Street in Gardner. This advertisement from the August 1929 issue of *Contact* magazine highlights all the electrical equipment in the diner. In 1954, Arthur L. Bernier, from nearby Winchendon, moved his diner, the Miss Toy Town (No. 815), to Gardner, replacing the Blue Moon. Years later, when Dennis "Skip" Scipione bought No. 815, he renamed it the Blue Moon, recalling the first diner at this address. (Courtesy of Larry Cultrera.)

The Worcester Lunch Car Company had cardboard tags printed and in use *c.* 1925. Their diners arrived on site with these tags marked to identify fuses, circuits, and other utilities for the gang installing the diner and completing the hookups.

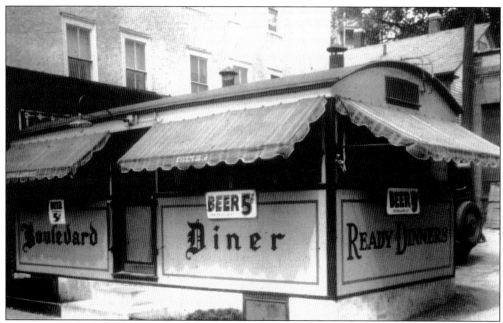

This photograph of the original Boulevard Diner has been displayed for decades in the "new" Boulevard Diner (No. 730) at 155 Shrewsbury Street in Worcester. Since the diner has been located on Shrewsbury Street for nearly seven decades, the nickel beer sign indicates the picture was taken between December 5, 1933, when Prohibition ended, and 1937, when the new diner was delivered.

The Tom Thumb (No. 669) is shown below in the 1970s at its last operational site, 42 Cummington Street in Boston. Built in 1932, it is shown above with its original name, Dempsey's. (The three men in aprons are unidentified.) It was brought to the location near Boston University in March 1949. Later, the exterior was severely altered with vertical siding and large picture windows installed. The interior remained intact with its two rows of stools that accommodated 20 patrons. It closed in February 1985 and was slated to reopen in Everett, Massachusetts, but never did.

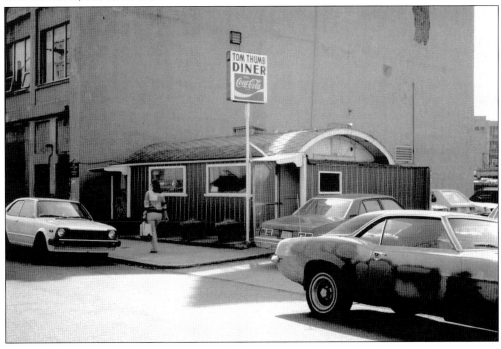

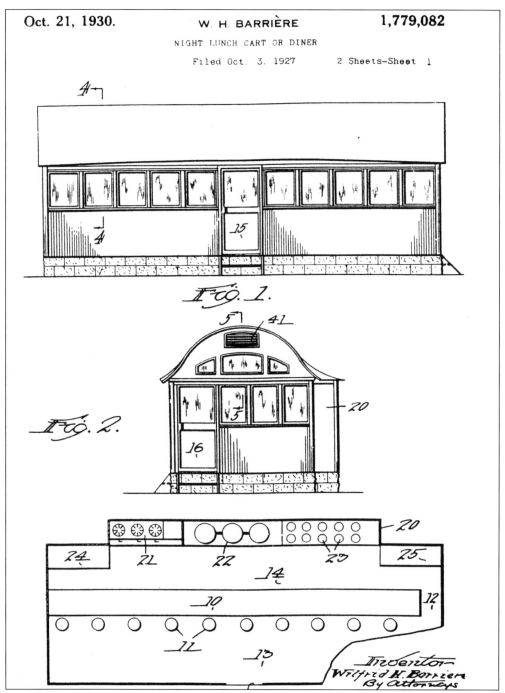

FIG. 1.

FIG. 2.

Inventor
Wilfred H. Barriere
By Attorneys

The Worcester Lunch Car Company encountered some local competition when former employee Wilfred H. Barriere began his own diner-manufacturing concern in 1926. He built the diners in his backyard on Cleveland Avenue in Worcester and also on site. On October 3, 1927, he applied for a patent of his design, which closely resembled a Worcester lunch car. As seen in these patent drawings, his diners had a higher, more prominent roof, with three windows in the end, and a bumped-out area in the back wall for the cooking equipment.

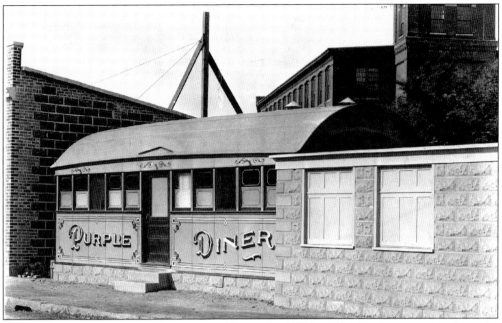

The Purple Diner was built by Barriere and located at 755 Southbridge Street, not far from the Worcester plant. The lettering and pinstriping on the diner's body are derivative of Worcester artwork. One can see the distinctive profile of the high barrel roof in this photograph. Its name refers to the nearby College of the Holy Cross, whose school color is purple. (Courtesy of the Worcester Historical Museum.)

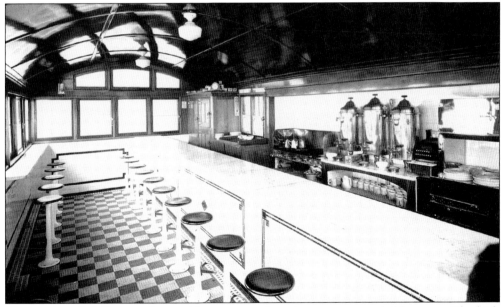

This unidentified Barriere diner, with two rows of stools, appears remarkably roomy. The high ceiling with three end windows lets in plenty of natural light, and the white marble counter reflects it throughout. The cooking line is recessed, as shown in the patent drawings, and gives extra space to those working behind the counter. The diner's tiling schemes are unique. (Courtesy of the Worcester Historical Museum.)

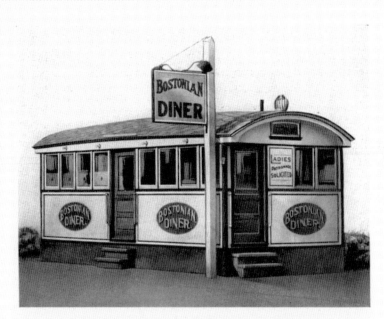

10′ 6″ x 22′ 3″ Worcester Diner

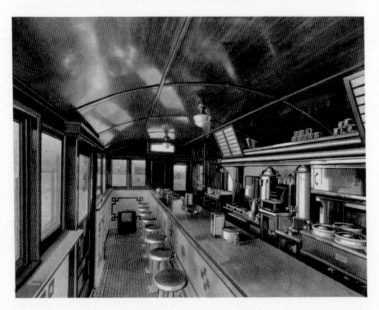

10′ 6″ x 22′ 3″ Worcester Diner

Only four catalogs and flyers are known to have been issued by the Worcester Lunch Car Company during its 55-year existence. The excerpts shown here and on the following pages appeared in a catalog sent in 1934 to a prospective buyer. The images on these two pages show the smallest diner offered by the company.

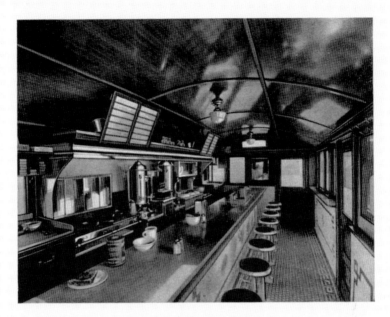

10′ 6″ x 22′ 3″ Worcester Diner

Body of Diner 10′ 6″ x 22′ 3″; Double roof; autumn blend asphalt shingles; tile floor; tile walls; two exhaust fans, German silver hood, steam table, one short order plate consisting of 2 open burners and a 2 burner Glenwood griddle, 6 crocks, overhead oven whole length of steam table, one oven gas range with 2 burners on top, one 3 gallon coffee urn, one 6 gallon hot water boiler, and eleven stools.

The cost for this diner in December 1934 was $6,625, if finished with tile walls on the inside. A cheaper version with wood walls brought the price down to $6,375. The wooden model is similar to Casey's Diner (see page 56).

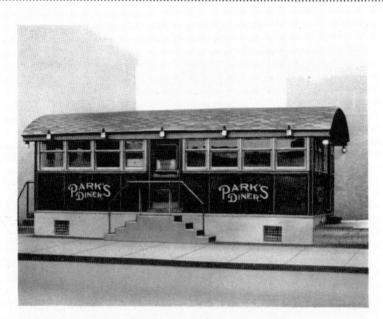

12' 6" x 26' 3" Worcester Diner

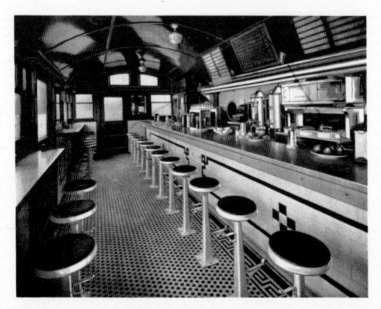

12' 6" x 26' 3" Worcester Diner

In this model, two feet were added to the width, allowing an extra row of stools at a shelf along the front windows. With four extra feet added to the length, the seating capacity was boosted to 24.

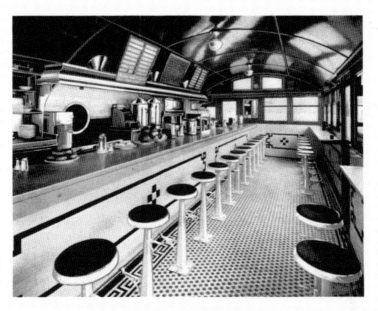

12' 6" x 26' 3" Worcester Diner

Body of Diner 12' 6" x 26' 3"; Double roof, autumn blend asphalt shingles, tile floor, tile walls, marble counter, two exhaust fans; German silver hood; steam table, 6 crocks, overhead oven whole length of steam table, one short order plate consisting of 3 open burners and a 2 burner Glenwood griddle, double oven range, with 3 top burners, 4 gallon coffee urn, 8 gallon hot water boiler, 2 gallon creamer, and twenty-four stools.

The cost for this model in December 1934 was $9,075, if finished with interior tile walls. The wooden-walls version came in at $8,525. Buddy's Truck Stop (see page 57) is an example of the tile style.

12' 6" x 36' Worcester Diner

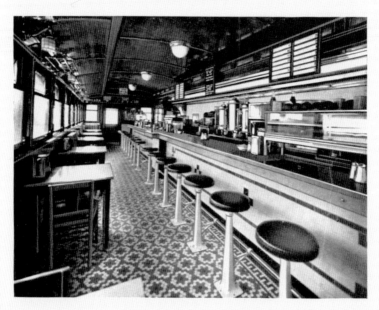

12' 6" x 36' Worcester Diner

In the late 1920s, Worcester reintroduced a monitor roof. It had a raised section with two rows of operable windows to allow more light and better ventilation. This diner also substituted deuce tables (for two patrons) for the extra row of stools.

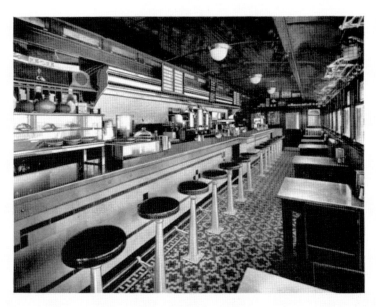

12' 6" x 36' Worcester Diner

Body of Diner 12' 6" x 36'; Monitor roof, autumn blend asphalt shingles; tile walls; tile floor; marble counter; three exhaust fans; German silver hood; steam table, 9 crocks, one meat roll, overhead oven, one short order plate consisting of 4 open burners and a 3 burner Glenwood griddle, 2 oven gas range with 3 top burners; 2 three gallon coffee urns, one ten gallon hot water boiler, 2 gallon creamer, sixteen stools and six tables.

The monitor roof significantly added to the cost. With tile walls, it was $14,025. It was $12,925 with wood walls. The Chadwick Square Diner (see page 74) is this type of lunch car.

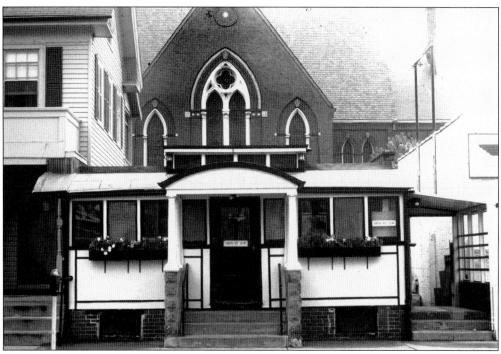

Casey's Diner, built in 1922, is the sole surviving example of an all-wood interior. It was purchased secondhand in 1927 by Fred Casey, who moved it from Framingham, Massachusetts, to nearby Natick. When Fred retired in 1952, his son Joe took over. Subsequently, Joe's son Fred and his son Patrick took over. For 50 years, the diner was a fixture in the center of Natick in "the Casey Block," seen above. In 1977, Casey's moved around the corner to 36 South Avenue, where it operates today. The photograph below, from 1980, shows the entire staff. From left to right are Bobby Bates, Jimmy Christie, and Fred Casey.

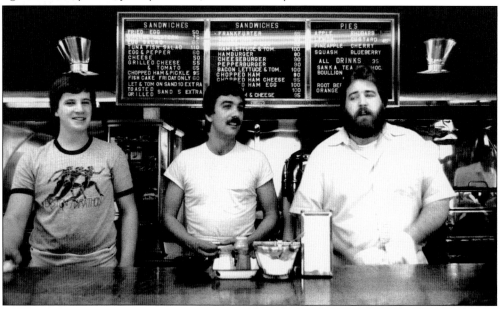

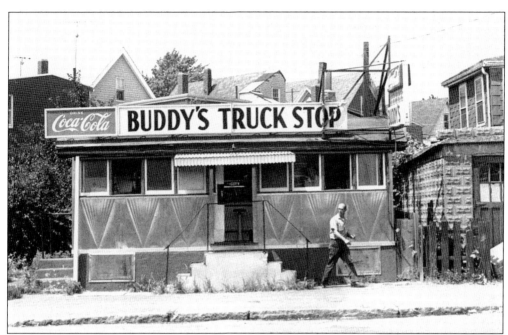

Buddy's Truck Stop (No. 624) first operated as Sawin's Diner in 1929 in Leominster, Massachusetts. In 1951, the diner was moved to 113 Washington Street in Somerville, and Alphonsus "Buddy" Barrett bought it in 1966. His children still run the diner. The inside is close to original, but the façade has the distinction of being clad in sunburst-patterned, stainless steel panels. Chef Kenny Barrett is shown to the right in the early 1970s during a lull at lunchtime. The Buddy's tradition of advertising the day's specials on paper plates suspended from the gumwood ceiling continues to this day.

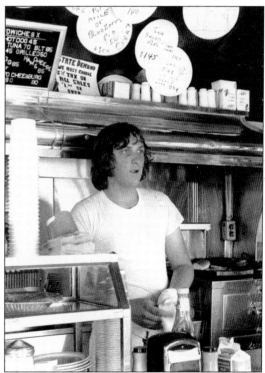

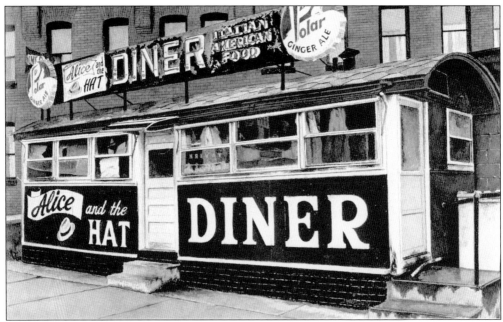

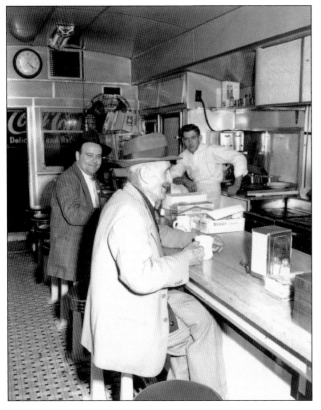

Alice and the Hat (No. 610) was the eponymous diner captured in this 1974 watercolor by John Baeder. Tom Carey, also known as "the Hat," was a sportswriter for the *Worcester Telegram and Gazette* in the 1950s. Alice was his wife. The diner still sits on Murray Street off Chandler in Worcester, but it was bricked over in 1979 for use as a real-estate office. "The Hat" was a true diner habitué. The photograph to the left shows Carey (foreground) in an unidentified diner with another newspaperman. The picture was taken by George Cocaine, also of the *Telegram*. (Above, courtesy of John Baeder; left, courtesy of the Worcester Historical Museum.)

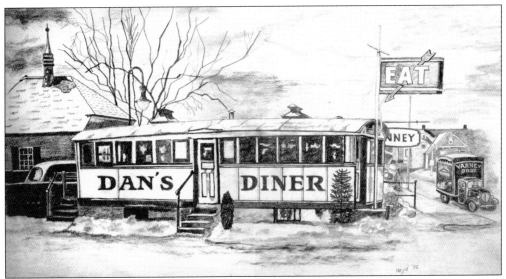

Dan's Diner operated at 1808 Centre Street in West Roxbury, Massachusetts, from 1929 to 1941. In 1941, Daniel Fitzpatrick upgraded to a Sterling diner. This pencil drawing was done by West Roxbury resident David Noyd, a retired sign painter. Dan's daughter, Ellen Fitzpatrick Runge, M.D., recalled, "I remember the EAT sign and drew it many times for school drawing at the Patrick Lyndon School. It was a neon flashing type and it fascinated me."

On June 7, 1932, J. Edward Parks opened his brand-new monitor-roofed diner (No. 698), replacing Art's Filling Station (see page 40). Located in Waterville, Maine, it was extremely popular with students from Colby College. One of the fraternity houses built this snow sculpture of the diner for Winter Carnival in 1938. Don Parks ran the place with his father and remarked that it was "probably the only diner ever built that just melted away."

For All Ye Hungry Folks
Late Supper Menu
A la Carte

GRILLED OR BROILED FANCY SIRLOIN STEAK
Choice of Vegetables French Fried Potatoes Bread and Butter
.60

GRIDIRON SCOTCH HAM
(Full Order)
French Fried Potatoes, Vegetable, Bread and Butter
.40

The Eternal Twins
Ham and Eggs

Grilled Scotch Cured Ham—with Two Fresh Country Eggs Fried or Scrambled
French Fried Potatoes Toast
.45

Aristocratic Hamburger
GRILLED FRESH GROUND HAMBURG STEAK (Full order)
Sliced Tomatoes or Chow Chow French Fried Potatoes
Bread and Butter
.45

BOILED ARLINGTON FRANKFORTS
French Fried Potatoes Home-made Chow Chow
Bread and Butter
.35

ALL GREEN FANCY ASPARAGUS TIPS
WITH DRAWN BUTTER
On Golden Brown Buttered Toast
.35

CANADIAN OR STAR BACON AND EGGS
French Fried Potatoes Bread and Butter
.45

You are now eat-ing in the Finest Dining Car in the Country **And—You are be-ing served quality Food—by clean ef-ficient young men**

The late-supper menu of the Flying Yankee Dining Car (No. 591) in Lynn, Massachusetts, dates from *c.* 1930. The use of the slang phrase "Eternal Twins" in reference to ham and eggs is unique, according to diner lingo expert John Clarke, who has never seen slang printed on a menu before. This item is also the only breakfast item offered, along with the steaks and frankforts. (Courtesy of Dave Waller.)

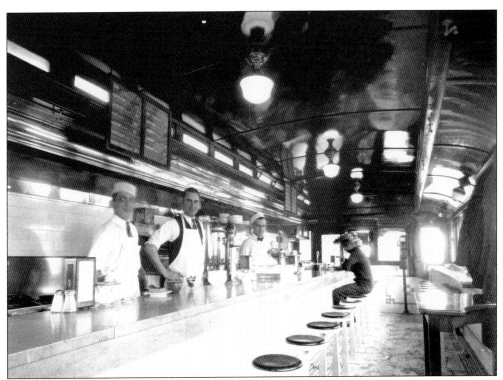

Jack Walsh and Jack Hines were partners in the Flying Yankee Dining Car, by the General Electric plant in Lynn. Hines is in the center of this picture. When they opened in 1928, they made several conscious decisions. They literally threw away the key, according to the newspaper ad below. They also decided not to court female business, believing women took too long to order and would hinder the turnover rate at the busy lunch rush. They fixed up a place in the basement, and all women were escorted to the cellar for their meals. The diner was bulldozed in 1954 to make way for a gas station. (Above and below, courtesy of Dave Waller.)

WE'VE THROWN THE KEY AWAY!
NEVER CLOSED!
OPEN 7 DAYS A WEEK 24 HOURS A DAY
FLYING YANKEE DINER
874 WESTERN AVENUE **LYNN**
BOOTH AND COUNTER SERVICE

WORCESTER LUNCH CAR COMPANY
Builders of Worcester Diners

4 QUINSIGAMOND AVENUE
Telephone 2-5887

WORCESTER, MASSACHUSETTS

October 4th, 1934

Mr. Walter Bramble,
61 Washington St:,
Quincy, Mass.

Dear Sir:

 We have your inquiry of October 1st, addressed to Pullman and Bradley, regarding Diners.

 We are enclosing, for your information, catalog together with list of prices.

 We have a few very attractive second-hand Diners, which we feel sure would appeal to you if you could come to Worcester by appointment and discuss the matter with us, and see our product completed and under construction.

 We hope to hear from you within a short time. In the meantime our representative will probably call on you within a few days.

 Please be assured of our desire to serve you in every way possible.

 Yours very truly,

 WORCESTER LUNCH CAR COMPANY,

 P. H. Duprey
 President.

PHD/B

During the Great Depression, when potential customers inquired about purchasing a diner, Philip H. Duprey always mentioned a lower-priced alternative: buying a second-hand unit that the company had acquired as a trade-in. The recipient of this letter, Walter Bramble, kept it for nearly 60 years. After reading about the author in a 1991 *Yankee* magazine article, Walter Bramble gave this rare correspondence, along with all the paperwork, to him.

Lou's Diner, on Bayley Street in Pawtucket, Rhode Island, is typical of the type that Worcester would recondition. Fred Crepeau, a cabinetmaker at the company, recalled that a piece of vacant land across Quinsigamond Avenue from the plant was sometimes filled with as many as six diners awaiting reconditioning. They never gave up on a diner. However, this 1975 picture was taken after the company closed. The diner did not survive.

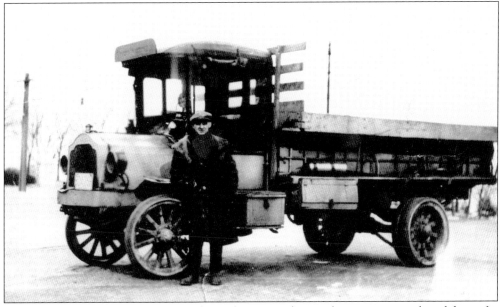

Shown in this image is Arthur H. LaFleur, who was in charge of moving new and used diners for the Worcester Lunch Car Company. LaFleur's crew included his son Henry, who later founded the Bancroft School of Massage Therapy in Worcester and was also a professional wrestler. His stage name was "Handsome Henry."

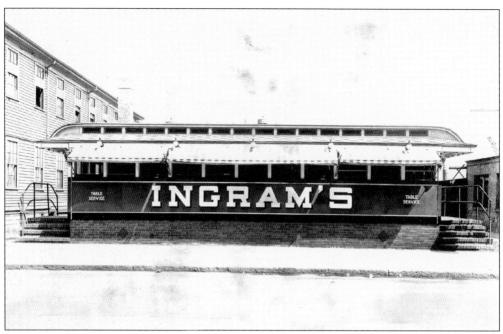

The locations of these two monitor-roofed models from the late 1920s are unidentified. Sullivan's was equipped with a row of deuce tables, while Ingram's had tables for four. Wilfred Bernard became the painting foreman at the company in 1930 at the age of 21; the lettering schemes were his work. Before porcelain enamel was widely used, the exterior paint job would last only three or four years. During the Great Depression, he spent a lot of time on the road repainting. One year, he was home only on weekends. (Above and below, courtesy of the Worcester Historical Museum.)

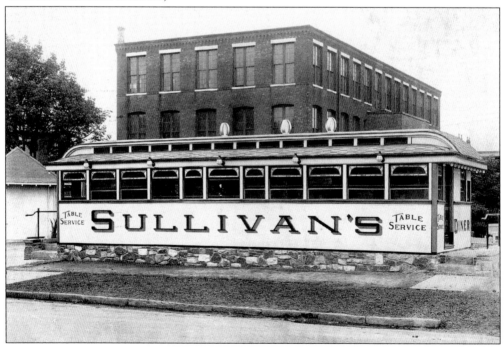

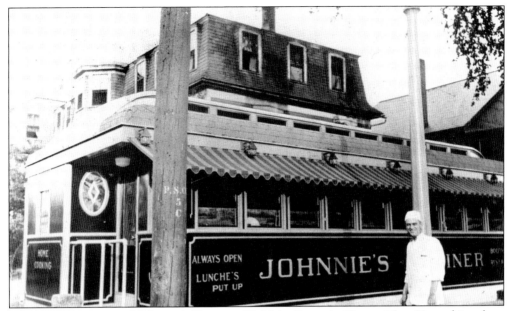

John A. Judge operated Johnnie's Diner at 92 Main Street in Keene, New Hampshire, from 1931 to 1937. This was the same location as Keene's first diner, Dee's Lunch Wagon (see pages 36–37). Judge used Dee's car as his kitchen, moving it 90 degrees so his new place could face Main Street. (Courtesy of the Historical Society of Cheshire County.)

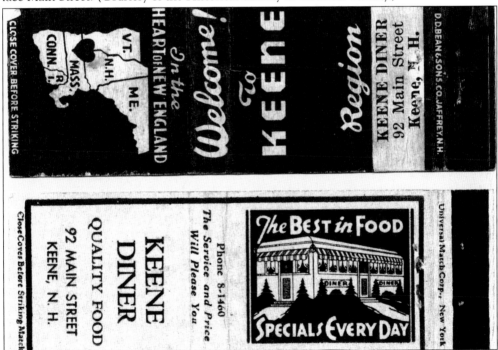

Johnnie's Diner was later known simply as the Keene Diner when William S. Demetre took it over and ran it during the 1940s. On the inside of these matchbooks are advertisements for the Quincy Market Food Shop at 103 Faneuil Hall Market in Boston, another restaurant run by the same people.

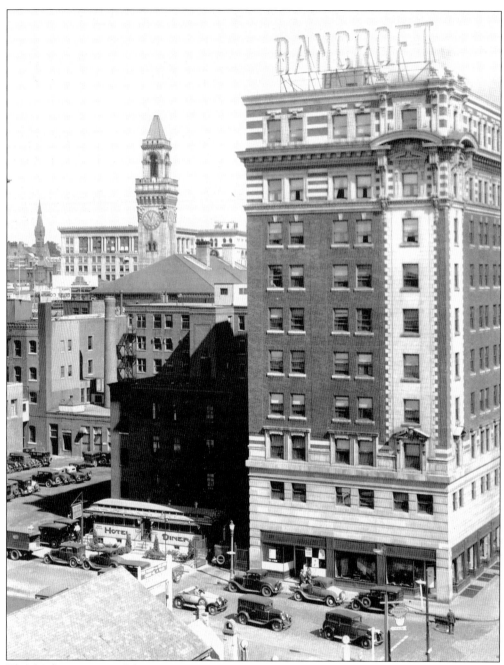

This bird's-eye view of downtown Worcester from the 1930s shows the Hotel Diner nestled into a plot of land at 41 Federal Street beside the Bancroft Hotel. Arthur LaFleur moved the diner from Warwick, Rhode Island, to the junction of Routes 9 and 20 near Worcester. At some point during this move, he became enamored of the diner and bought it in 1932 for his wife, Bertha, to run. It was later taken over by William B. Burns. In 1949, Burns lost his lease, and in August the diner was yanked from its foundation. It still had wheels when it was hauled away by LaFleur to Southbridge Street, where the company took it back under its wing. The diner's fate is unknown. (Photograph by E. B. Luce.)

Charlie Gemme kept a notebook with the details of steel requirements for framing diners. Around 1928, he listed standard sizes for wheels, with sizes of spokes, heights, and steel tires, which would correspond to diners of various sizes. The diners were built right on the wheels they were later moved on. Sometimes, when a diner was moved decades later, the wheels were discovered intact. (Courtesy of the Worcester Historical Museum.)

After 50 years on Route 12 in Leominster, Massachusetts, the Central Square Diner was lifted by riggers from its foundation in 1986 for a 100-mile trip to Kensington, Connecticut. When the brick foundation was broken away, the diner's original wheels were revealed. Two are now on display in the exhibition entitled Diners: Still Cookin' in the 21st Century, at the Culinary Archives & Museum at Johnson & Wales University in Providence, Rhode Island.

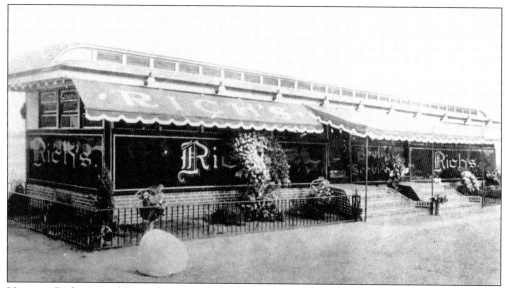

Herman Rich opened his red-and-gold 60-foot Worcester lunch car, Rich's Diner (No. 696), on June 1, 1932, at 175 State Street in Newburyport, Massachusetts. It had two doors in the middle to handle the crowds. When the diner arrived in Newburyport on May 7, two workers were sent from the factory to level it. For their combined 25 hours of work, the pair received a total of $18.20. (Courtesy of Don LaPlante.)

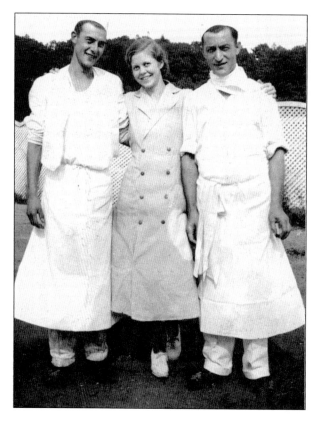

Rich's dishwasher George Parsons (left) poses with his future wife, Wilda, who also worked in the kitchen. Chef Tony Tripodi stands with them outside the diner in 1933. (Courtesy of Don LaPlante.)

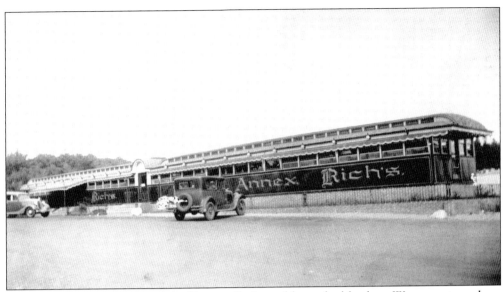

Business immediately boomed for Herman Rich, and he rushed back to Worcester to order a second 60-foot car, with booth service only. The annex (No. 708) was delivered exactly one year later. According to Worcester Lunch Car factory workers, Rich paid for his diners with suitcases full of cash, allegedly from bootleg liquor. (Courtesy of Don LaPlante.)

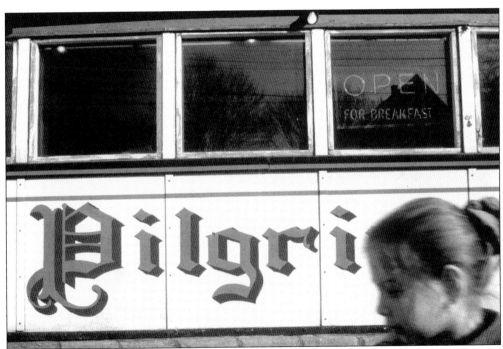

Sometime in the early 1930s, a customer wanted his diner lettered in an Old English style. Head painter Wilfred Bernard recalled, "I don't know who wanted it, but I had to buy a book and learn it. It came natural." Maybe not that naturally, as his coworker Fred Crepeau said, "Wilfred, he'd have his book out, saying, 'How do you make a D?' " This is his work on the Pilgrim (No. 725). It was sent to Salem, Massachusetts, in 1934.

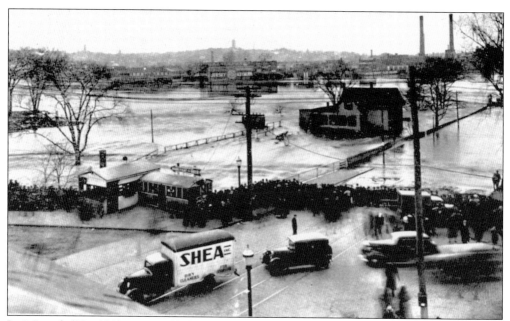

Joe's Lunch (No. 322) was installed by Joe Elward on the bank of the South Canal in Lawrence in 1918. When the Merrimac River flooded over the Great Stone Dam in 1936, hundreds of people lined up to gawk, giving the appearance of a long queue at the diner.

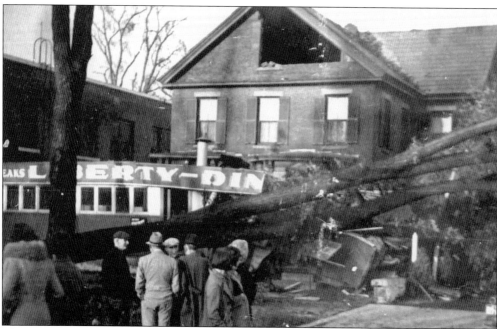

The Great New England Hurricane of 1938 was one of the most destructive storms in memory. It crashed ashore on September 21 and did not weaken. The Liberty Diner, on Main Street in Keene, New Hampshire, was one of the many buildings to be destroyed when 90-mile-per-hour winds hit. Keene suffered $1 million in damages. Some 2,000 trees were lost, cars were flattened, and homes and business were destroyed. (Courtesy of the Historical Society of Cheshire County.)

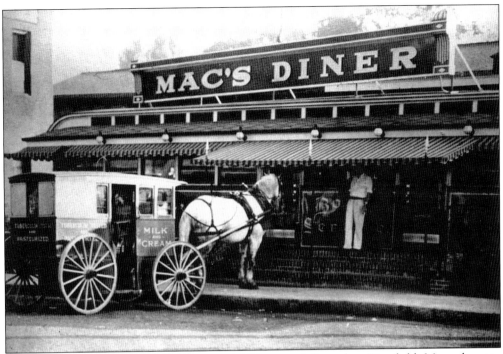

Mac's Diner (No. 702), named for owner McKay, was delivered to Westfield, Massachusetts, on September 22, 1932. It later moved to Northampton, where a photographer captured the milk-delivery wagon and the horse stepping onto the sidewalk, practically in the front door.

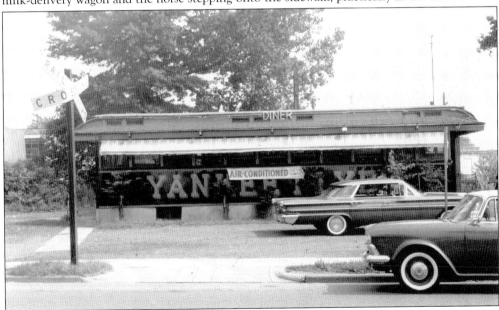

The Yankee Flyer (No. 657) was built in 1930 for Bill Reich and Chris Kyriax of Nashua, New Hampshire. It opened on April 16 at 236 Main Street. Their success led them to replace the Worcester with a Sterling Streamliner in 1940. This picture of the old diner, in a new, unknown location, was snapped in 1959 by diner renovator Erwin Fedkenheuer Jr., who was continually on the lookout for old diners to transform.

BREAKFAST SUGGESTIONS

Parks' Coffee with Cream 5c

Doughnuts, two for 5c	Buttered Toast 10c
Muffins, two for 5c	Cereals with Cream ... 15c
Fruits in season 10c	French Toast 30c
Two Eggs, any style ... 30c	Ham or Bacon and Eggs 40c
Griddle Cakes ... 20c—with Bacon ... 35c	

BREAKFAST COMBINATIONS

1. Fruit or Cereal, Muffins or Doughnuts, and Parks' Coffee 20c

2. Fruit, one Egg any style, Muffins, and Parks' Coffee 25c

3. Bacon or Ham and Egg, Toast or Muffins, and Parks' Coffee 30c

4. Fruit, Bacon or Ham and Egg, Toast or Muffins, Parks' Coffee . . 40c

5. Fruit or Cereal, Griddle Cakes and Bacon, and Parks' Coffee 45c

6. Fruit or Cereal, Minute Steak, Fried Potatoes, Toast, Parks' Coffee . 65c

SANDWICHES

Grilled hamburg	10c	Cold sliced ham	10c
American cheese	10c	Cold minced ham	10c
Cream cheese & olive	10c	Cream cheese & jelly	10c
Western	15c	Ham and cheese	15c
Bacon and egg	15c	Ham and egg	15c
Grilled cheese	15c	Tomato and lettuce	15c
Tomato and bacon	20c	Tuna fish salad	20c
Crabmeat salad	25c	Cold sliced chicken	25c
Chicken salad	25c	Chicken club	50c

(On toast, 5 cents extra)

A La CARTE

Heavy sirloin steak, French fries	85c
Minute sirloin steak, French fries	60c
Grilled hamburg steak, French fries	30c
Grilled Scotch ham steak	35c
Ham or bacon and eggs	40c
Ham, cheese or jelly omelet	40c
Tuna fish salad, French fries	30c
Crabmeat salad, French fries	40c
Scrambled eggs on toast	30c
Asparagus tips on toast	30c

Donald W. Parks, along with his father, J. Edward, opened Parks' Diner (No. 698) at 11 A.M. on June 7, 1932, in Waterville, Maine. This menu, described by Don Parks (at age 81 in 1987) as the only one still in existence, lists prices that never changed for the 16 years they owned the diner. Don called it "the million-dollar diner, almost." The gross receipts totaled $940,058.60, nearly reaching that magic number.

All Classes Eat In Dining Cars Today

Speed and Cleanliness Are Features of New Industry

Modern Diner Called Most Democratic And Most American of Nation's Eating Places

The *Waterville Morning Sentinel* for Tuesday, June 7, 1932, devoted half a page to the opening of Parks' Diner. Don Parks wrote all five of the articles, touting the modern details of the new diner, including the revolutionary idea of equipping it with a complete soda fountain. The younger Parks had four years of newspaper work under his belt in Portland before he joined his father in the diner business.

SPECIAL 55¢ SUPPERS

Roast sirloin of beef, squash,
mashed potatoes, hot rolls,
choice of pastry, tea, coffee
or milk.

OR

Chicken pie, squash, mashed
potatoes, hot rolls, choice
of dessert, tea, coffee, or mil

SPECIAL 50¢ SUPPER

Braised beef and vegetables,
mashed potatoes, hot rolls,
choice of dessert, tea, coffee
or milk.

SPECIAL 45¢ SUPPER

Tuna fish and egg salad,
french fries, hot rolls,
choice of dessert, tea, coffee
or milk.

SPECIAL 40¢ SUPPERS

Hamburg and spaghetti, mashed
potatoes, hot rolls, choice
of dessert, tea, coffee, milk.

OR

Baked beans & frankforts,
hot rolls, choice of dessert,
tea, coffee, or milk.

OR

Hot hamburg sandwich, mashed
potatoes, choice of dessert,
tea, coffee, or milk.

Parks' Diner had specials that changed daily for the noon and evening meals. Monday noon the feature was pot roast, Tuesday it was roast turkey, Wednesday was roast pork or lamb, Thursday was boiled dinner, Friday was haddock, or halibut, or swordfish, or all three, Saturday was prime rib or roast sirloin of beef, and Sunday was turkey again or a chicken dish. The evening specials were minute sirloin steak, calves liver and bacon, fried scallops, grilled ham steak, and others, which escaped Parks's memory 40 years later.

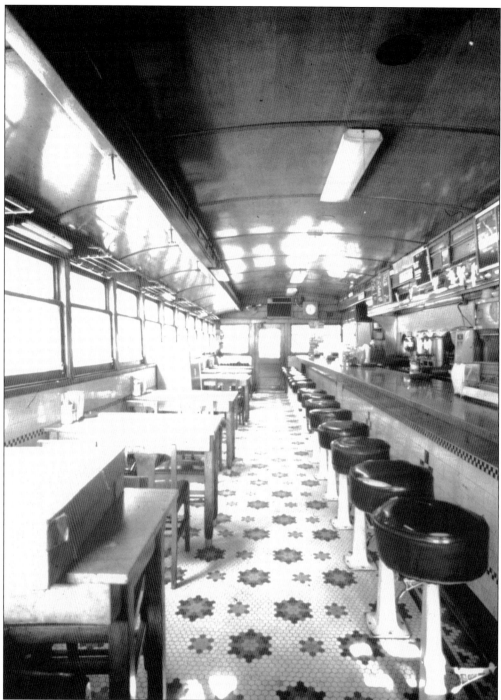

This Chadwick Square Diner (No. 660) replaced a 10-stool barrel-roofed model in 1930. It was forced from its first location in Chadwick Square, Worcester, in 1956, when the Guaranty Bank and Trust Company wanted the land for a branch. The diner moved to Cherry Valley, just west of Worcester, where this photograph was taken in 1974. The picture shows the beautiful tile patterns and marble-topped tables for four in an interior that remained unaltered.

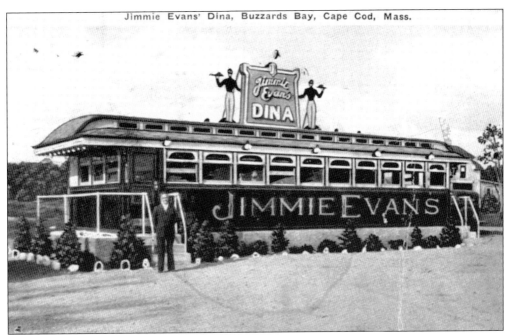

Jimmie Evans ran not only this diner but also the Jimmie Evans Revue on B. F. Keith's eastern vaudeville circuit. This *c.* 1930 postcard tempts motorists headed for Cape Cod to "let Jimmie Evans tickle your palate in the same manner that he pleased you in the theatre." The sign is a play on the Boston pronunciation of the word "diner."

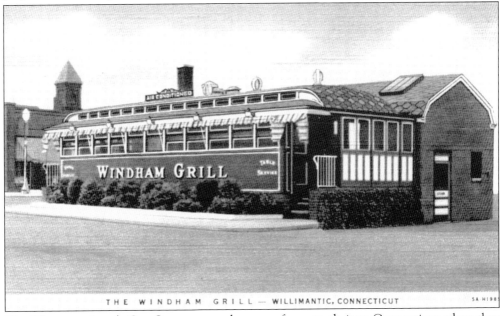

The Worcester Lunch Car Company made a rare foray south into Connecticut when they delivered the Windham Grill (No. 688) to Stephen Chontos in 1931. This postcard was printed in 1935, and the back listed a few facts from the previous year's sales. More than 300,000 patrons were served, requiring 6 tons of hamburg, over 200,000 cups of coffee, $5^{1}/_{2}$ tons of sugar, and 96,000 eggs. (Courtesy of Arthur Goody.)

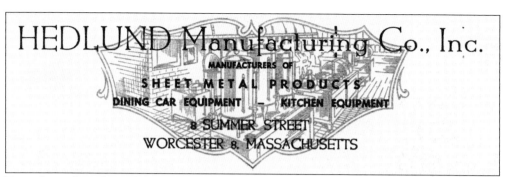

HEDLUND Manufacturing Co., Inc.

MANUFACTURERS OF

SHEET METAL PRODUCTS

DINING CAR EQUIPMENT — KITCHEN EQUIPMENT

8 SUMMER STREET
WORCESTER 8, MASSACHUSETTS

From the earliest days of their operation, Worcester utilized several other local businesses for subcontracting work. Marble workers Carlo and Alfred Bianchi did much of the ceramic tiling work. Victor Hedlund's metal-working business, Hedlund Manufacturing Company, built all the urns, steam tables, sinks, hoods, fans, and other specialty metal items. When the iceboxes needed to be lined in stainless steel, Hedlund did it. The cast-bronze tag below was one of two mounted on the German silver hood made by Hedlund for the diner last known as Hodgin's (No. 272) (see page 35).

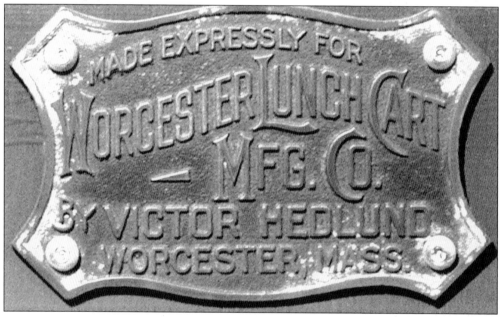

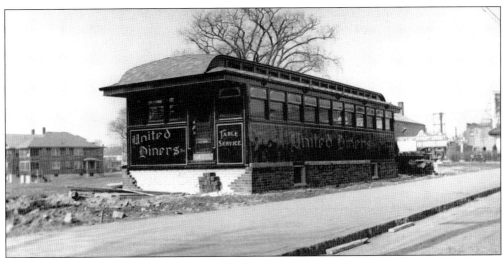

The United Diner (No. 692), at 699 Hancock Street in Quincy, Massachusetts, was one of three units in the United Diner chain, operated by the Georgenes family. Proudly, the exterior was emblazoned with the words "United Diners." The Quincy diner was photographed in February 1932 as the foundation was being bricked in. The diner was demolished in 1967. (Courtesy of the Thomas Crane Public Library.)

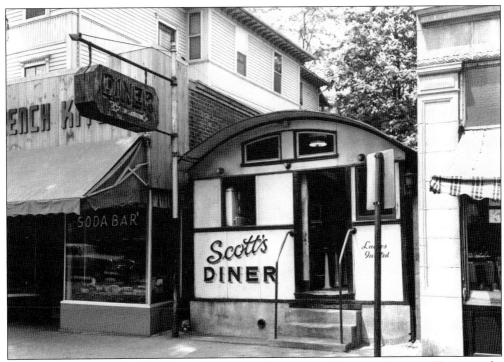

John P. Scott, known as "Skitchy," owned Scott's Diner, at 317 Pleasant Street in Worcester, for 38 years. His 1965 obituary in the *Worcester Gazette* said that "during that time both he and the diner became landmarks." Regulars included politicians, city employees, and former athletes, prompting a range of conversation that would cover "almost any subject." Two years before he died, he sold the diner to Edward A. Hart. (Courtesy of the Worcester Historical Museum.)

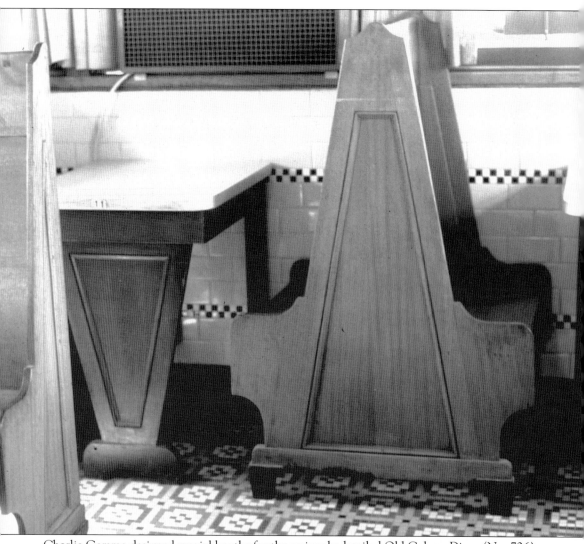

Charlie Gemme designed special booths for the uniquely detailed Old Colony Diner (No. 726). They were surprisingly reminiscent of church pews. In fact, Worcester did a lot of jobbing for local churches—building pews, lecterns, and related items. His brother Louis made them. Fred Crepeau, awaiting the booths to apply stain, remarked about Louis Gemme, "He was so fussy that you used to get fed up with him. It had to be perfect or it wouldn't leave his area." The company took pride in their woodworking. Crepeau continued, "We had one guy—all he did was sandpaper and smooth wood. That was his job. He was an older guy, too, and he loved it. You'd bring him big pieces of mahogany, eight or ten inches wide, fourteen feet long, and he'd plane them and sand them, with rough, then fine sandpaper. Then he'd move to the moldings, and stick them in the corner for the guys to use when they got to them. He'd do that all day long."

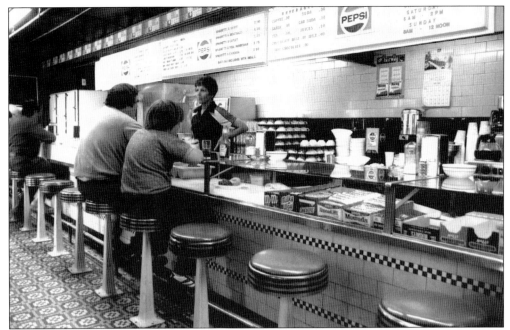

The Old Colony Diner (No. 726) was originally the flagship in the Georgenes family chain of five Worcester diners in the Boston area. It was built in 1936 and located in South Boston. By the 1970s (this picture was taken in 1980), it had been moved to Route 110 in Dracut, Massachusetts, where Leo Dalphond ran it until 1986. At that time, it was gutted, and the building was used as storage for the adjacent Chinese restaurant. With the exception of the stool tops, the beautiful interior was still original, including the elaborate tiling, porcelain enamel icebox, gumwood ceiling, and mahogany booths. The special glass counter built to display pies was still intact.

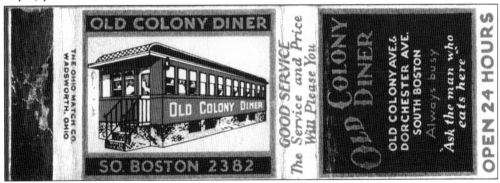

Pop Fleming ran a popular 10-stool Worcester lunch car at 10 Water Street, Posner Square, in Worcester. During World War II, his loyal customers sent season's greetings and inquired after the other regulars: "Do you have many Saturday night drunks, well wait till we get back." When they returned, the gang posed for a snapshot with Pop, affectionately known as "Fathead," in front of the diner. The ancient diner was demolished *c.* 1960, but the brick warehouse still stands. It is now the Arrow Wholesale Company, a distributor of chain-store merchandise. (Above and below, courtesy of Ruth Ann Penka.)

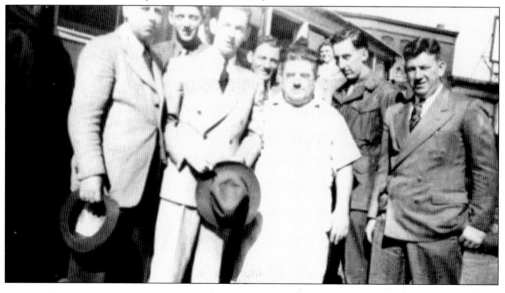

Four

WHEELED WONDERS

A lion's share of the success of the Worcester Lunch Car Company could be attributed to Yankee thrift and conservatism—both on the part of the company, which turned out essentially the same model year after year, and in part due to the preferences of the owner, who was perfectly happy with what was being offered.

Of course, another reason was the loyal patronage of the diner's customers. There have been countless stories of regulars who have eaten meals on a daily basis at their favorite diner for decades.

Tradition played another role. In several New England cities, the custom of mobile diners continued far past the era of the "owl wagon," which was pulled by a horse into its spot each night. When these old wagons wore out, the operator often went back to Worcester with a truck and had a diner built right on the back.

Providence, Rhode Island, Portsmouth, New Hampshire, and Fall River and Taunton, Massachusetts, were all strongholds of diner trucks. In Providence, the Haven Brothers began with a White House Café in 1893. They graduated to a Wilfred Barriere in 1906 and kept replacing their successors as required.

Al McDermott operated a string of mobile and stationary diners in Fall River. In 1929, the *Worcester Daily Telegram* ran a story on the completion of the McDermott Brothers' 65-foot-long diner under the headline "Lunch Car Built Here May Be World's Largest." Within three years, he ordered two other smaller diners. Then, 10 years later, he added a mobile diner (No. 744) to his fleet.

Al Mac, as he was known, and others like him, enjoyed their routine. They did not mind working the night-owl shift and were grateful for the nominal rent. They paid for only a parking space and utilities hookup. The cities looked upon these anachronisms with favorable nostalgia. Each new model was grandfathered in to avoid regulations that might have precluded its operation.

Taunton was unusual. The Taunton Green was punctuated regularly with as many as four wagons, one set up on each side. An ordinance dating from the 19th century permitted the wagons to operate from 4:00 P.M. until 2:00 A.M. Even though the wagons were upgraded when needed, some were still horse-drawn as late as 1938.

Thanks to the wonderful tradition (since 1914) of Christmas decorations on the Taunton Green, there is a photographic record of the mobile diners that operated there. The elaborate lighting was well documented over the years, and many wagons appear at the corners of these photographs, surrounded by cars and sometimes covered by snow. John F. Hickey was the last remaining lunch wagon man when, in 1985, he pulled the plug after 42 years of operation on the southeast side of the green.

The Taunton Green is shown on a late afternoon around Christmastime in 1931. The display that year had the added attraction of Santa Claus and his reindeer. More than one lunch wagon can be seen in the photograph, and the two horses that pulled Galligan's Café are still hanging around, waiting to be led back to their stable. Taunton diner man Jack Hickey began work at Galligan's in 1942. (Courtesy of the Old Colony Historical Society, Taunton, Massachusetts.)

Between 1934 (above) and 1939 (below), Behan's Diner (No. 719) got a new paint job. The dark color scheme made it stand out in the snowscape. These images are details from larger photographs. Taunton was strapped for cash during this time, and the decorations were more subdued than in former years. (Above, courtesy of William F. Hanna; below, courtesy of the Old Colony Historical Society, Taunton, Massachusetts.)

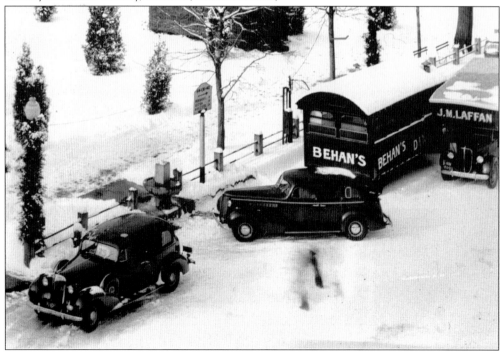

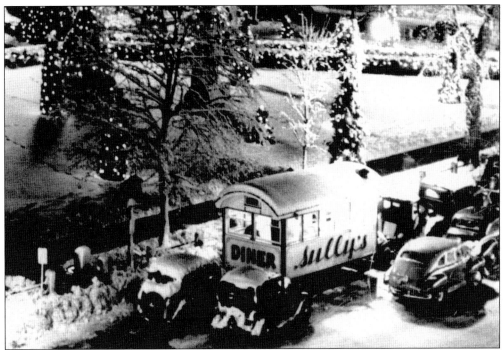

Sully's Diner (above) was extremely popular on this cold, snowy night in 1948. At least seven cars surround the diner, with plenty of double parking, in this detail from a picture of the entire Taunton Green. Hickey's Diner (No. 798) was the last of the mobile diners to do daily business on the green. Beginning in 1966, Jack Hickey had the common to himself. He is shown below in 1974. Hickey designed his 10-stool diner with Charlie Gemme in 1947 and operated it for four decades before calling it quits. (Above, courtesy of the Old Colony Historical Society, Taunton, Massachusetts.)

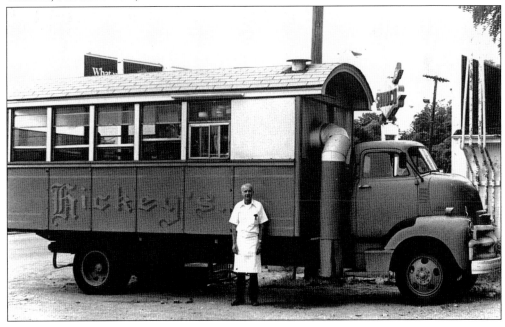

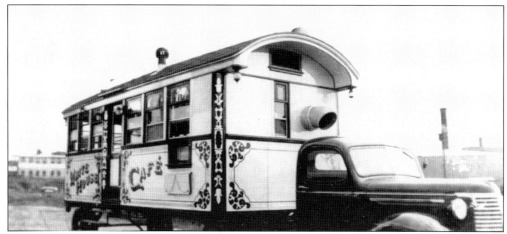

Al McDermott loved big diners and little diners. Here are two of his mobile units. The White House Café (No. 744) was built in 1939, and the Nite Owl (No. 786) dates from 1945. Al Mac knew his diner history well enough to name these wandering wagons appropriately.

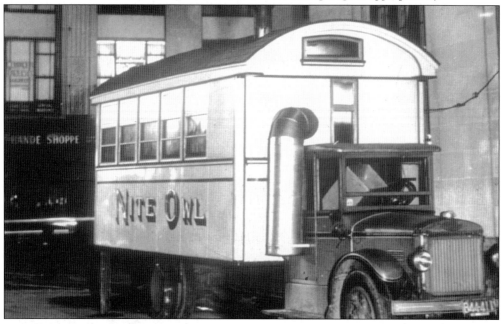

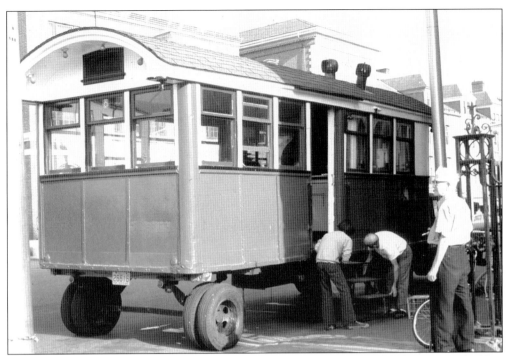

In 1941, McDermott sold the White House Café to William Kennedy of Portsmouth, New Hampshire. Kennedy had been operating lunch carts in Market Square since 1916. The diner soon lost its fancy paint job and was known as Kennedy's Lunch Cart. From World War II until his retirement in 1974, the night shift was run by Ralph "Gilley" Gilbert, shown putting the steps in place and assembling some hamburgers. By 1974, Gilley had worked his way into the *Guinness Book of Records*. Every day for 15 years, he paid a 50¢ parking fine ticketed to the diner, amassing more than 5,000 violations. The diner still operates in Portsmouth at 175 Fleet Street.

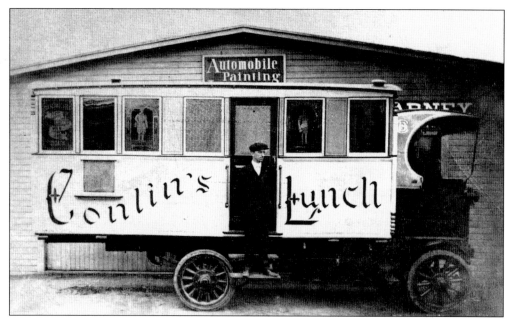

Daniel N. Conlin was looking backwards and toward the future when he bought Worcester Lunch Car No. 310 in 1918. He wanted the mobility but not the horse, so he had this unique hybrid built for him to ply his trade in Providence. Perhaps the painting shop behind the diner added some extra scrollwork to the cab of his truck, where his initials are visible. (Courtesy of John Baeder.)

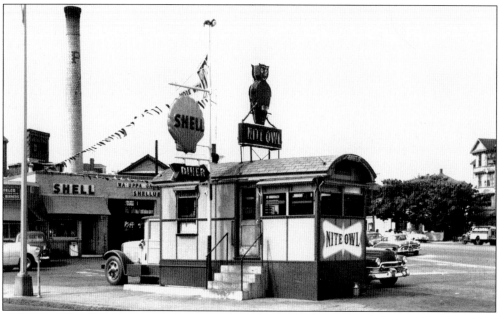

Al Mac's other World War II diner, the Nite Owl (see page 86), lost its wheels within a decade. Immobilized at 1680 Pleasant Street in Fall River, the Nite Owl added a sign for better visibility. In 1956, the proprietor bought a stainless steel diner from DeRaffele Manufacturing, in New Rochelle, New York, and the two operated briefly side-by-side. Not long after, the old Worcester lunch car disappeared. (Courtesy of John Baeder.)

Five

THE STREAMLINE ERA

During the 1930s, while the country was trying to shake the Great Depression, industrial designers began to give a new look to everyday objects. Streamlining was a forward-looking aesthetic that implied movement; therefore, it implied a better future. Products ranging from record turntables to toasters, and from automobiles to locomotives, were redesigned to appear as if they were on the move, even if they were not going anywhere.

Especially in terms of architecture, streamlining was all imagery; it went beyond efficiency. A teardrop design applied to a stationary building was more a statement than a functional requirement. It was modern, it was new, and it would catch the eye of the public.

Diners were perfectly suited to be repackaged in a streamlined form, and soon the shiny surfaces were made to appear even glossier. The basic shape of a diner was already long and low, but now the exterior skin was transformed with gleaming, colorful porcelain enamel panels, replacing the painted sheet metal.

The Worcester Lunch Car Company introduced a new design in 1939, noted as "streamline" in their record books. It had a monitor roof, like a railroad car, and end walls that were slanted at 10 degrees off plumb. The first one, Murphy's Diner (No. 743), was built for Joseph F. Murphy and installed at 2525 Massachusetts Avenue in Cambridge, Massachusetts. Over the next eight years, they built a total of 23 diners in this style.

Worcester's competitor in Massachusetts, Sterling Diners, of Merrimac, introduced a bullet-nosed streamliner the following year. Sterling was the diner division of the J. B. Judkins Company, which began building carriages in 1857. They had switched to motorcar bodies in 1910, but the Great Depression ended the call for custom automobile work, and they retooled once more and began building diners in 1935. Eventually, Sterling built 20 streamliners (their total output was 76 diners), with one or both ends configured in a bullet shape, before they shut down manufacturing for good in 1942.

Not to be outdone, Worcester developed a similar model. The design was conceived on a piece of kraft paper by Wilfred Bernard, Worcester's painting foreman. Bernard was Charlie Gemme's nephew, and he had started as a carpenter at age 16 but was injured in an accident. He lost an eye and could not hit a nail, so he became a painter, because he had always "liked to scribble and draw." Bernard sketched only the curved end of the diner and took it to Gemme, who invariably needed to add his input: "If it didn't come direct from him, then it wasn't a good idea." Then, the whole crew worked on making Bernard's complicated design a reality.

The diner (No. 757) was constructed for Peter Calimaris of Quincy, Massachusetts, and it had two bullet-shaped ends. It was referred to as a "circular diner," and the mahogany trim proved very difficult for the cabinetmakers because of the curves. However, the company was extremely proud of it. It was one of only two built, and they used it prominently in advertisements for years.

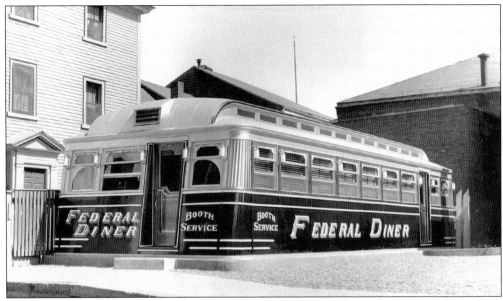

The Federal Diner (No. 746), built in 1938, was one of the earliest streamline diners made by Worcester. The diner's initial location was in Salem, Massachusetts. The angled sides are visible in this shot, which shows the main entrance set into the slanted end wall. The door's window has an unusual configuration, as do the small windows flanking it. The new italic typeface was well suited to the aesthetic. (Courtesy of the Worcester Historical Museum.)

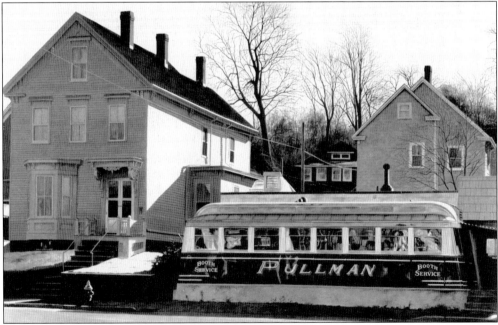

The Pullman (No. 756) was originally located in Charlestown, Massachusetts, but is shown here on Massachusetts Avenue in Arlington. This is a reproduction of a 1974 oil painting by John Baeder, measuring 60 by 72 inches. The name was apt for this sleek diner, clad in black porcelain enamel with gold and green lettering, including a silvery metal roof. By 1976, the diner had been demolished for a branch bank. (Courtesy of John Baeder.)

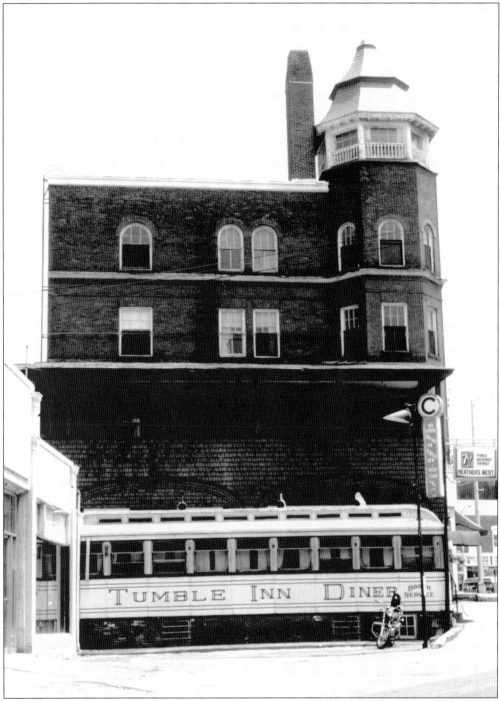

The Tumble Inn Diner (No. 778) was truly one of a kind. Charlie Gemme's steel framing record book noted that this diner had "no slant on ends" but "rounded corners same as streamline." Sent to Claremont, New Hampshire, in 1941, it is still in operation. In addition to the unique end wall configuration, the lettering on the façade was done in a style they never repeated.

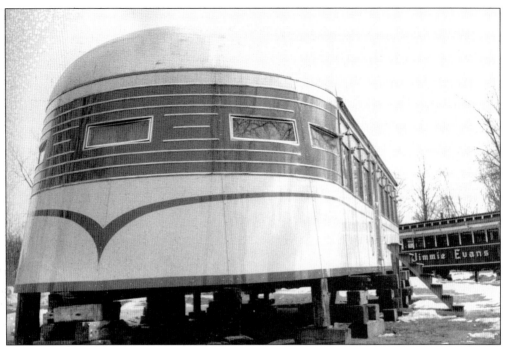

This view of the lot adjacent to the Sterling Diners plant in Merrimac, Massachusetts, shows a newly completed Sterling Streamliner ready for shipment, with an old Worcester lurking behind. Sterling got the Worcester as a trade-in when they sold Jimmie Evans a new Streamliner—the Jimmie Evans Flyer in 1941. Rectangular windows were awkwardly placed into the curved façade, and these diners developed quite a reputation for leaking in the end walls.

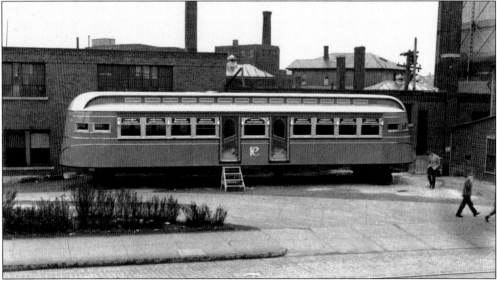

The Mayflower Diner (No. 757) was Worcester's answer to the Sterling Streamliner, and it bears a fairly strong resemblance to its inspiration. This huge diner was built for Peter Calimaris, whose initials are in the porcelain enamel panel between the doors. It sat alongside the Southbridge Street side of the Worcester plant before being hauled to the Southern Artery in Quincy, Massachusetts, in May 1940.

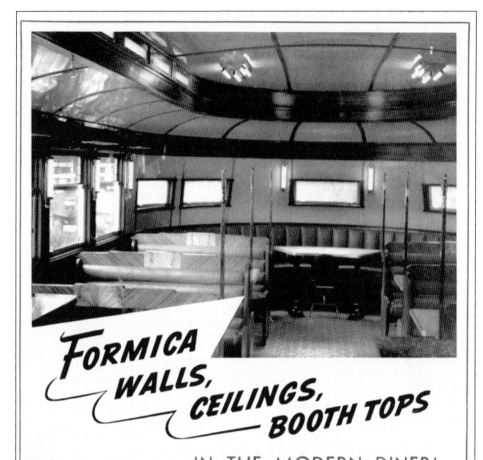

FORMICA WALLS, CEILINGS, BOOTH TOPS

—IN THE MODERN DINER!

THROUGH a liberal use of Formica on walls, ceilings, table tops, the Mayflower Diner, at 473 Southern Artery, Quincy, Mass., is one of the most modern and appealing restaurants in town. Its good looks pull in the crowds.

With the help of Formica you can have at moderate cost, beautiful, sanitary and easily cleaned surfaces which will make your establishment always attractive to the public. There is a wide range of fadeless colors that maintain their original appearance indefinitely.

There are good reasons why so many hundreds of fine new diners are making such a liberal use of Formica. Be sure that you ask about it when you buy a new car. The one shown in the picture was made by the Worcester Lunch Car Company.

Literature showing colors, sent on request.

The Formica Insulation Company, 4662 Spring Grove Ave., Cincinnati, Ohio

FOR FURNITURE, FIXTURES AND BUILDING PURPOSES

With a touch of irony that was probably lost on those who saw this, the Formica Insulation Company used the interior of the Mayflower Diner to illustrate their latest offerings in November 1941. The copywriter had to specifically refer to "booth tops," as the rest of the bench seating was built the traditional Worcester way: solid mahogany. This diner was replaced in 1948 by a big Jerry O'Mahony diner on the Southern Artery location. That diner, in turn, was demolished in 1978 to make way for a McDonald's. The original Worcester streamliner became the Wonderland Diner by the racetrack in Revere, Massachusetts. It burned in 1959.

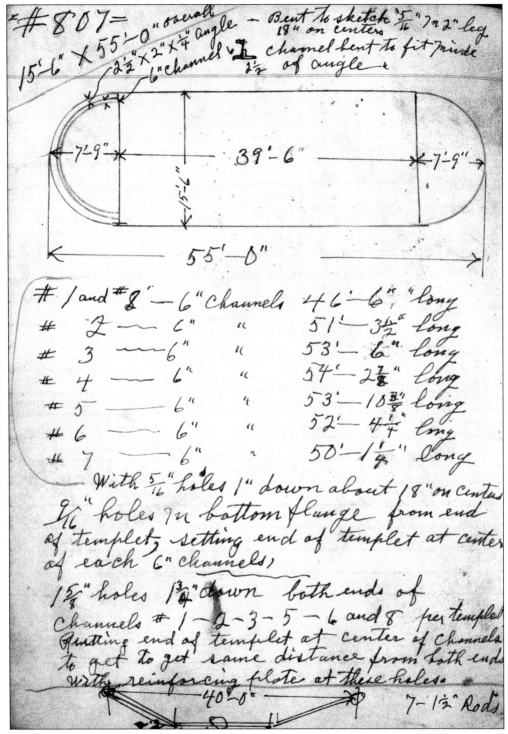

*#807=
15'-6" X 55'-0" overall - Bent to sketch 5/16" 7"x2" leg
2½"x2"x¼" angle 18" on centers
6" channel 1 channel bent to fit inside
2½ of angle

7'-9" — 39'-6" — 7'-9"
1'-5'-6"
55'-0"

1 and #8 — 6" channels 46'-6" "long
2 — 6" " 51'-3½" long
3 — 6" " 53'-6" long
4 — 6" " 54'-2⅞" long
5 — 6" " 53'-10⅜" long
6 — 6" " 52'-4¼" long
7 — 6" " 50'-1¼" long

With 5/16" holes 1" down about 18" on centers
9/16" holes in bottom flange from end
of templet, setting end of templet at center
of each 6" channels)

1⅝" holes 1¾" down both ends of
channels # 1 - 2 - 3 - 5 - 6 and 8 per templet
Putting end of templet at center of channels
to get to get same distance from both ends
with reinforcing plate at these holes.

40'-0"
7 - 1½" Rods

The second and final circular diner built by Worcester required two full pages of notes and diagrams for the steel framing specifications. Usually, only a few lines were needed. This diner

94

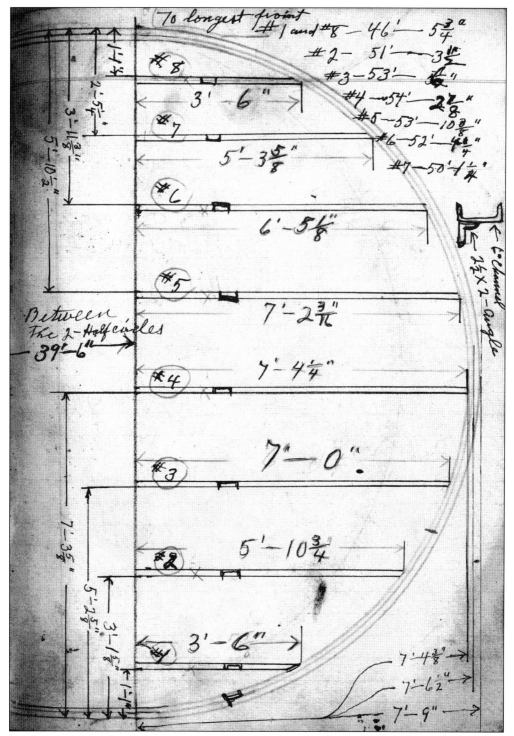

To longest front
#1 and #8 — 46' — 5¾" a
#2 — 51' — 3½"
#3 — 53' — 5½"
#4 — 54' — 2⅞"
#5 — 53' — 10⅜"
#6 — 52' — 4¼"
#7 — 50'-4¼"

#8
3' — 6"

#7
5' — 3⅝"

#6
6' — 5⅛"

#5
7' — 2 3/16"

Between
The 2-Half circles
— 39'-6"

#4
7' — 4¼"

#3
7" — 0".

#2
5' — 10¾"

#1
3' — 6"

7'-4⅜"
7'-6½"
7'-9"

← 6" Channel
2¼ × 2 Angle

(No. 807) was the Yankee Clipper and, at 15 feet 6 inches wide, was one of the widest they had built to date. (Opposite and above, courtesy of the Worcester Historical Museum.)

95

YOU CAN'T LOSE YOUR DINER WHEN YOU BUY YOUR DINER FROM US

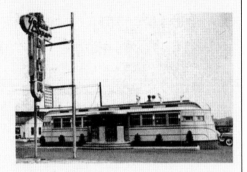

When times are good, payments are easy; when times get tough, we make the terms easier.

In the meantime, you are operating America's finest custom made diner SUCCESSFULLY without a worry or care as to your payments. Your investment in a Worcester Diner is always protected by our willingness to make our terms fit the times.

Write today for complete information.

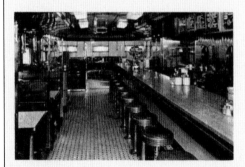

First in 1904; definitely first today!

WORCESTER
LUNCH CAR CO.
Pioneer builders of modern diners

4 Quinsagamond St. Worcester, Mass.

The Yankee Clipper is featured in this Worcester advertisement from the October 1950 issue of *The Diner and Counter Restaurant*. At the time, the diner was already three years old. This style was passé after World War II, but Worcester evidently did not realize that. Even more curiously, they were still using "Lunch Car" in the company's name.

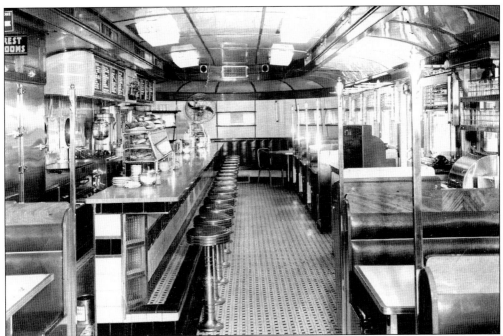

The interior of the Yankee Clipper is shown shortly after it opened at 594 Valley Street in Providence. Advertising proclaimed the Yankee Clipper to be "Rhode Island's Most Streamlined Diner," and it was undoubtedly true. However, the inside gave evidence of Worcester's traditional materials and detailing: the same tile patterns, hood design, and mahogany trim. Only the circular end set it apart from their other monitor-roofed diners. The photograph below was taken in 1974, not long before the diner was razed. (Above, courtesy of the Worcester Historical Museum; below, courtesy of John Baeder.)

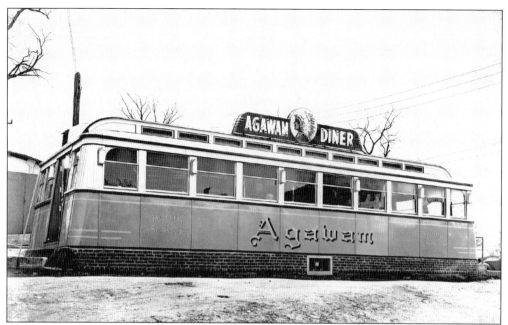

The Agawam Diner (No. 797) was built for the Galanis family and delivered to Depot Square in Ipswich, Massachusetts, on Lincoln's Birthday in 1947. Seven years later, a big double-wide Fodero diner replaced this streamliner, which was moved to Salem, where it operated as the North Shore Diner before demolition. (Courtesy of the Worcester Historical Museum.)

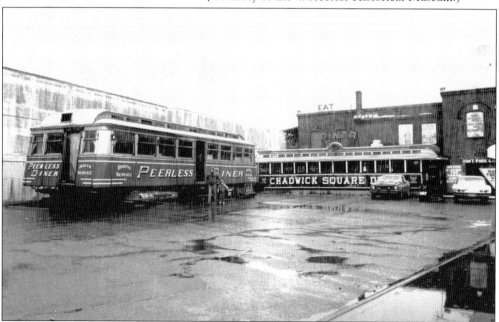

The Peerless Diner (No. 764) is shown in this 1987 image, in the rainy parking lot of the Chadwick Square Diner in Worcester. It was en route to an ill-fated end in Key West, Florida. The Peerless was too large to fit across the bridges it encountered. On its way to the southernmost city in the continental United States, it was sliced lengthwise and never recovered. The diner had opened in 1940 in Lawrence, Massachusetts, and was demolished in 1990.

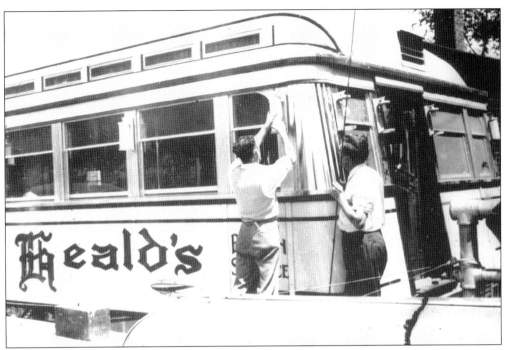

When a diner was transported to its site, extraneous pieces (such as light fixtures) were removed so they would not get knocked off during transport. Part of the installation process was installing the exterior lights and ensuring they worked properly. Heald's Diner (No. 790) was sent to Gardiner, Maine, where Arthur LaFleur snapped some pictures of the unidentified crew at work. These porcelain enamel fixtures were custom made for Worcester; two extra were provided to flank the front door of Charlie Gemme's house on Plantation Street.

Worcester's last diner order before shutting down production during World War II was in 1942. This was Whit's Diner (No. 783), built for the Whitney brothers (see page 124). Two years later, on November 31, 1944, Charlie Gemme placed a steel order for No. 784, but this diner, Duffy's, was not delivered until December 3, 1945. In the interim, as part of the war effort, the company constructed this food wagon for the Worcester Chapter of the American Red Cross. (Above and below, courtesy of the Worcester Historical Museum.)

Six

WORCESTER
STANDS PAT

For their 1947 catalog, Philip H. Duprey wrote an open letter to prospective operators. He described the company as "the pioneer builder of dining cars." The stationery's letterhead included a cut of the Old Colony Diner, arguably one of their most beautiful units. However, it was 11 years old when the catalog was distributed.

This was indicative of a company that was mired in the past. Although they would build to any size, they were still offering an 11-seat diner that was 10 feet 6 inches wide and 20 feet long. The largest of the four diner models illustrated in the brochure was a streamliner with a seating capacity of 50.

The year before, Jerry O'Mahony Inc., of Elizabeth, New Jersey, the largest diner manufacturer of the day, built the immense Deluxe Diner in Union, New Jersey, with a seating capacity of 153.

The popularity of diners boomed after World War II, and the prosperity of the 1950s was a golden age for them. Worcester got off to a strong start when construction resumed in 1945, selling 14 diners in 1946, and 12 in 1947. Then, things got tougher.

More companies popped up at that time, and the competition was the beginning of the end for Worcester. The other builders, concentrated in the metropolitan New York and New Jersey areas, built ever larger stainless steel–clad diners to satisfy the growing demand for seats.

These Jersey-style diners had large windows, curved glass corners, and a new roofline that gave them a boxier look, de-emphasizing the vehicle imagery. Inside, the short-order range and sandwich board moved from behind the counter to a closed-door kitchen in the rear. The large volume of work could no longer be handled by the short-order cook at the backbar.

Even into the mid-1950s, the Worcester Lunch Car Company (even its name was old-fashioned) continued to use wood trim and wooden booths on the interior when the competition had long before switched to stainless steel and chrome. Potential buyers had been complaining for years that Worcester was not building anything up-to-date. It was not until 1952 that the company finally added some stainless steel to the porcelain enamel on the outside of its diners.

Philip Duprey, still in charge since Worcester's inception in 1906, refused to put any money into the company to retool. They continued to turn out essentially the same model, which by now virtually no one wanted. Although they sold four diners in 1955, they did not sell their next one, which was their last, until May 1957. Worcester Lunch Car No. 850, Lloyd's Diner, went to Johnston, Rhode Island.

It did not completely end. For four more years, Charlie Gemme tried in vain to peddle renovations and the occasional new diner. Finally, at 3:01 P.M. on Tuesday, May 23, 1961, auctioneer Henry A. Berman completed a liquidation of the company's assets with this announcement: "The sale is over." At age 77, Gemme was forced into retirement. Within four hours, the contents of the factory had been sold off to the highest bidders.

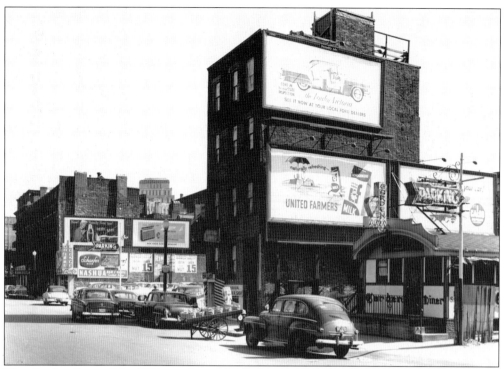

The Garden Diner (No. 739) was located at 34 Nashua Street, around the corner from the Boston Garden in the West End of Boston. Whether or not Bruins or Celtics ate there, it surely did great business before and after games. This picture was taken in 1956, when the diner had been at Nashua Street for 18 years. It was demolished in the mid-1970s. (Photograph by Nishan Bichajian, courtesy of the Kepes-Lynch Collection, Rotch Visual Collections, MIT.)

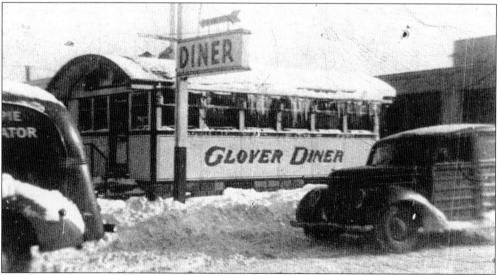

Arthur Blair owned several diners in the Boston area during the World War II era. The Glover (No. 754) was delivered to Dorchester Avenue in the Dorchester neighborhood of Boston, on November 9, 1939. It was a traditional barrel-roofed model but had the italic lettering style found usually on streamliners. Former counterman Bernie Dodd provided this photograph.

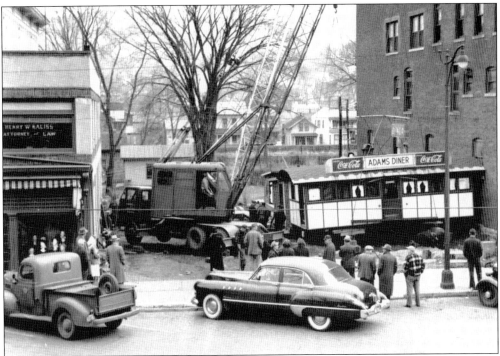

On December 7, 1949, owner Joseph J. Wilusz was undoubtedly part of the crowd watching a crane move his old diner off its foundation at 53 Park Street in Adams, Massachusetts. In the photograph below, the old car is still there, complete with its rooftop neon sign, behind the new one (No. 821). Perhaps Wilusz kept it open while final preparations were made to inaugurate the Miss Adams. The diner had a new roofline with rounded ends added to the usual barrel configuration. (Above and below, courtesy of the Adams Historical Society.)

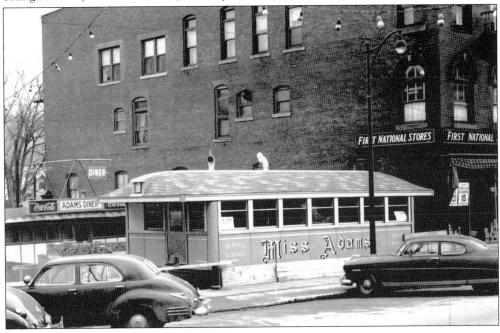

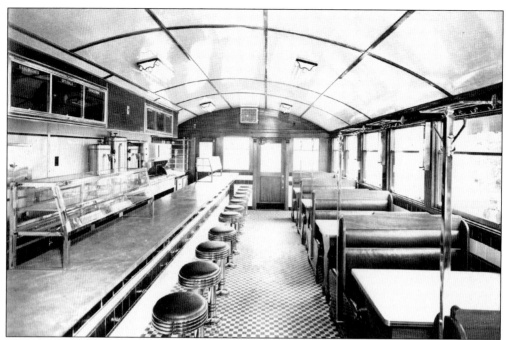

These two photographs illustrate Worcester's interior designs after World War II—both the barrel roof (unidentified) and the monitor (Blair's Diner No. 799) styles. Worcester's competition was now using terrazzo floors instead of ceramic mosaics. They replaced wall tile with Formica, booths were chrome or fully upholstered, and it seemed everyone except Worcester was using stainless steel on the backbar instead of porcelain enamel. The sunburst-pattern stainless-steel backbar was an option Worcester offered that cost customers extra. (Above and below, courtesy of the Worcester Historical Museum.)

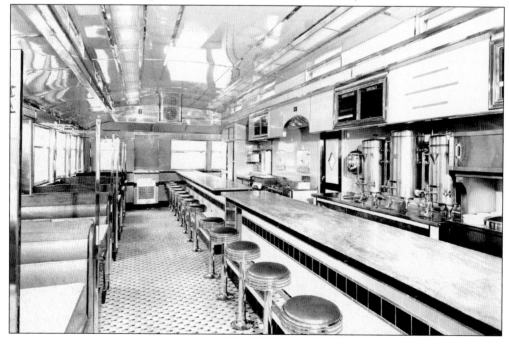

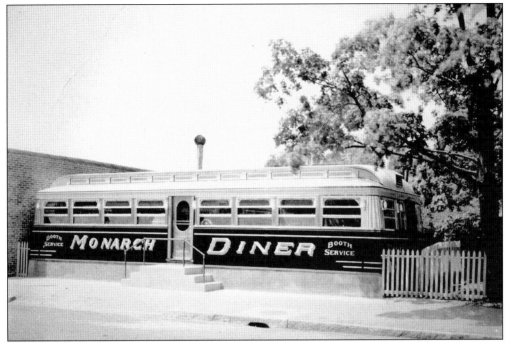

The Decola family had a 22-diner dynasty but was best known for a chain of Monarch Diners. The first Monarch was a streamliner (No. 759) that opened in Waltham, Massachusetts, at 789 Main Street in June 1940. When the Decolas wanted to replace the streamliner with a bigger unit, Worcester did not offer them anything they liked, so they bought a big stainless job from Jerry O'Mahony Inc. The picture below shows the two side-by-side, briefly. Soon after, the old diner was moved to Lowell, where it became the Owl Diner. (Above and below, courtesy of Louis Decola and Larry Cultrera.)

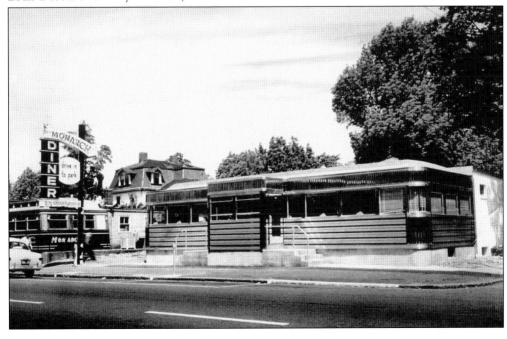

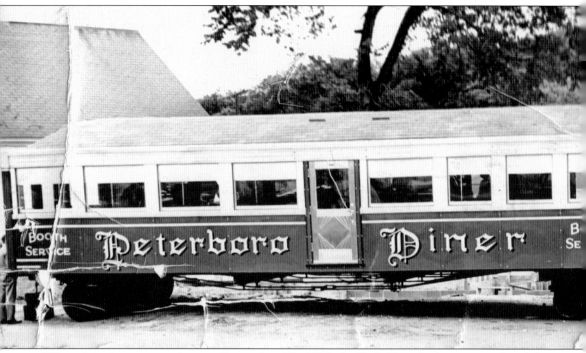

When this picture was taken on September 20, 1950, A. H. LaFleur had just arrived at 10 Depot Street in Peterborough, New Hampshire, with No. 827. The diner's foundation is barely visible in this tattered photograph. Milton and Barbara Fontaine were the proud owners of the

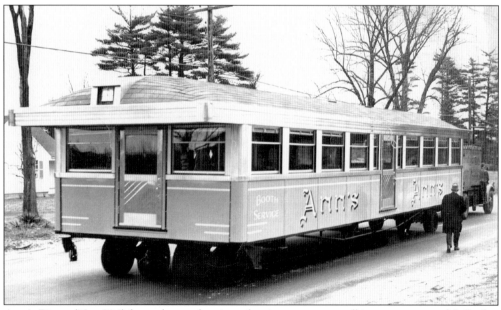

Ann's Diner (No. 824) hogs the road as it makes its way, at a walking pace, toward 9 Bridge Road in Salisbury, Massachusetts. James F. Evans was the owner, and he named the big diner for his wife, Ann. The left end had a dining room with six big booths, which could be closed off from the main area by a wide pocket door. (Courtesy of the Worcester Historical Museum.)

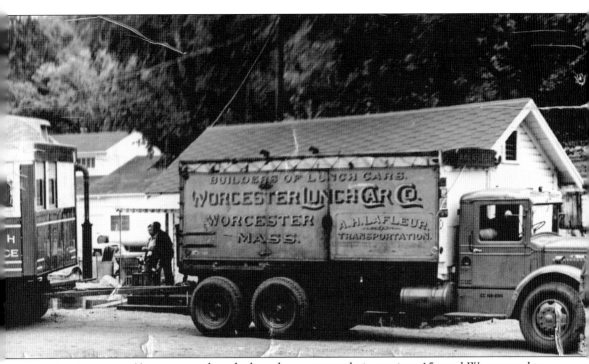

pine-tree green 41-seater, purchased when they outgrew their previous 15-stool Worcester that had originally been Art's Filling Station (see page 40).

Even after moving diners for decades, the LaFleur outfit carried these crib sheets with notes to ensure the trip went smoothly. This to-do list for moving a used diner dates from the 1950s and reminds the crew foreman to "disconnect everything under the diner" before jacking it up to load onto the trailer. LaFleur Transportation outlasted the Worcester Lunch Car Company and was still moving diners in the mid-1960s.

cut the roof away so we can jack Diner up straight

disconnect everything under Diner

put everything loose in Diner on the Floor — cigarette machine — make sure nothing is loose

Break foundation in front to let in light to see for disconnecting

2 Sledge Hammers	
2 pipe wrenches	crow bar
pinch bars	Hack saws and blades
Hammers	saw
search lights	small sledge
ladder	
Hydraulic Jacks	

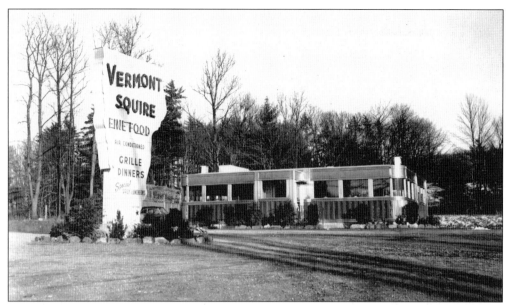

The Vermont Squire (No. 845) was the only two-section diner ever built by the Worcester Lunch Car Company. It was sent to Brattleboro, Vermont, in June 1954. On June 6 of that year, the newspaper reported that the kitchen was on site at Putney Road, and the "eating section" was slated to arrive the following day. Each of the two pieces was 16 by 42 feet, and Worcester also built a matching vestibule. The sign, in the configuration of the state of Vermont, is especially noteworthy.

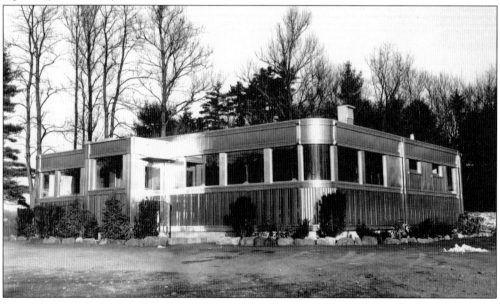

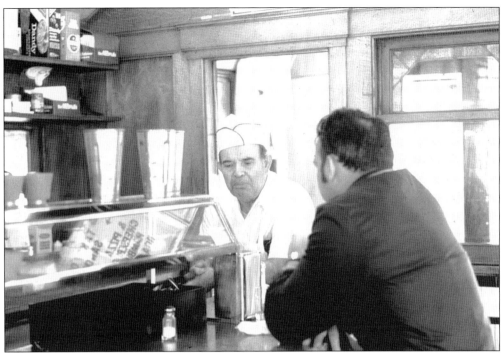

Jimmie Limperopoulis was the last owner of the Black and Gold Diner, outside Roslindale Square in Boston. The diner was constructed for Peter F. Charlton in the early days of World War II and delivered in March 1942. In this 1973 image (above), Jimmie bears the weight of the world while in conversation with a customer. Two years later, the diner was demolished to make room for a parking lot. Several pieces were salvaged by the author. The menu board, with its 1975 prices intact, is on display at the diner exhibition at the Culinary Archives & Museum at Johnson & Wales University in Providence.

Where shall we eat? *What shall we eat?*

A satisfying answer awaits you at

JIMMIE'S BLACK and GOLD DINER

(Roslindale Square)

Only the best served here

4142 WASHINGTON STREET
ROSLINDALE, MASS.

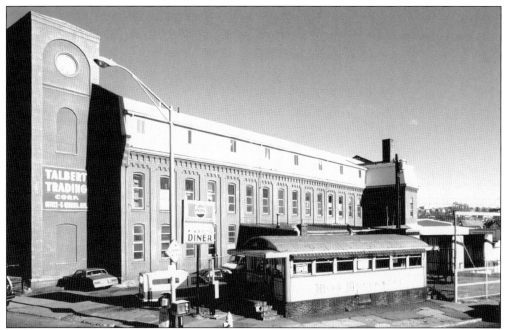

The Miss Worcester (No. 812) stood directly across from the plant and was referred to as the factory showcase. It was owned by Dino Sotiropoules, who had operated an older car, the Star, which had seen better days. Since Philip Duprey owned the land, in 1948 he said, "I want you to put a new diner on this corner lot. If you don't, I am not going to renew your lease." Dino acquiesced.

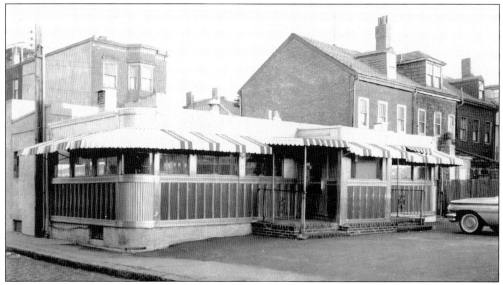

Cabinetmaker Fred Crepeau commented on Charles Gemme's stodginess: "Charlie never went way out. He'd just stick to the old standby. The only thing you could argue with Charlie would be the size—and where do you want to put your doors?" Eventually, the company adopted a new aesthetic with stainless steel and fluted porcelain enamel. This late model, Connolly's (No. 847), from 1955, built for Joseph Capellano in Charlestown, Massachusetts, is typical. (Courtesy of the Worcester Historical Museum.)

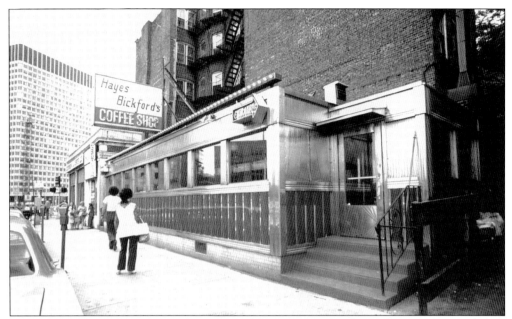

The Hayes-Bickford restaurant chain opened a Worcester lunch car (No. 848) in Bowdoin Square, Boston, when they acquired Barr's Diner from Hugh Fountain. This boxy diner, shown in 1971, had a stainless and green porcelain exterior. A newspaper clipping commented on the generous width of the diner: "The stools, too, are well spaced so that the person on the adjacent stool will not be jostled by the coming and going of other diners." The diner has not survived.

Lloyd's Diner (No. 850) was the last diner built by Worcester. It was delivered to 2760 Hartford Avenue in Johnston, Rhode Island, in May 1957. This picture was taken in 1980, when it was still going strong. By 1989, the diner embarked on a series of moves, taking it to Weymouth, Massachusetts, and Bridgehampton, New York. It ended up on Route 104 in New Hampton, New Hampshire, in 1994, with the name Bobby's Girl.

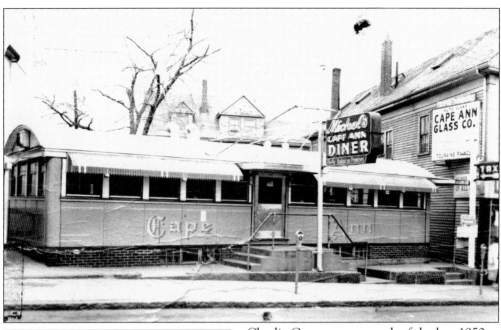

Charlie Gemme spent much of the late 1950s trying to drum up business. He kept a catalog of note cards identifying diners by serial number. The Cape Ann (No. 813) was sent to Gloucester, Massachusetts, in 1948. It was bought by Roland Michel four years later, as noted by Gemme. When it was sold again, he made another notation (left) but did not know its fate. The photo postcard (above) was damaged from being tacked to his bulletin board for years. On October 29, 1980, the diner was auctioned, moving to Danvers, where it became the Portside. (Note card courtesy of the Worcester Historical Museum.)

Seven

The End and the Beginning

The Worcester Lunch Car Company is no more. However, around 90 of their diners still exist. Some of these have remained in the same families for generations, and the spatula has been turned over to the children, grandchildren, and great-grandchildren. Yet as time moves on, some of these old Worcester lunch cars will bite the dust. Others will be reborn as they change hands.

The portability of diners has always been one of their most desirable features. If business "went south," the diner could follow. Thus, the itinerant nature of diners, as shown throughout this book, is nothing new.

What is new (since c. 1980) is the rescue and renaissance of older diners, which in former times would more likely have been demolished. During the last quarter-century, diners have achieved an iconic status that has elevated them way beyond their function as good places for a quick meal.

Diners are now movie stars. The Kitchenette (No. 594) was used in 1978 for a brief scene in *The Brink's Job,* where the robbers stopped for a meal. Skip's Blue Moon Diner (No. 815) was a hangout for students in the 1992 film *School Ties.*

Diners are now in museums, sometimes serving food, sometimes serving up history lessons. For some reason, motorcycle dealers have a special fondness for diners. Among the diners to appear in their showrooms alongside the Harleys is a Worcester lunch car, the former Leo's Diner (No. 796).

The preservation of diners has helped to solidify their place in American culture, as well as their place in the architectural landscape of our cities and towns. A couple of Worcesters have even left our shores for England.

Today, some people purchase diners just to collect them, not to run a restaurant. Other entrepreneurs have been professionally trained at the Culinary Institute of America or Johnson & Wales University. This is a far cry from those who first tried their hand at running lunch wagons. A sampling of those early diner operators in Worcester c. 1900 shows they'd switched careers from shoemaking, wire working, stonecutting, or stage managing to sling hash.

In 1978, the first diner was listed on the National Register of Historic Places. This did not happen without controversy, as preservationists had a justly earned penchant for historic houses, not the commercial vernacular. The first diner, however, was not built by Worcester; rather, it was a Sterling Streamliner—the Modern Diner, of Pawtucket, Rhode Island.

Others followed, and the first Worcester lunch car made the register in 1983—the Miss Bellows Falls Diner (No. 771) of Bellows Falls, Vermont. More recently, a dozen Worcester diners have been included in multiple property listings on the national register, nominated by the Massachusetts Historical Commission.

Although the Worcester Lunch Car Company is long gone, the legacy of diners they have left behind endures, thanks to the customers who patronize them and the owners who are their caretakers.

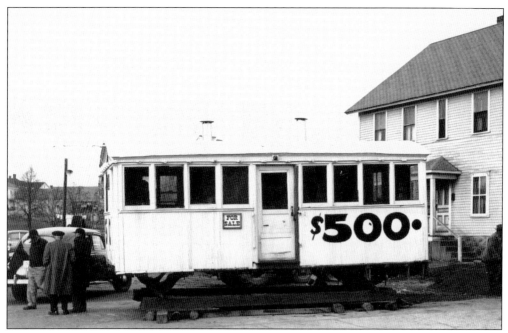

A diner on blocks has always aroused interest. This old Worcester lunch car belonged to Fred Moran, who operated it on the site of what became Panciera Chevrolet, 339 Main Street, in Wakefield, Rhode Island. It was up for sale *c.* 1950 and sat along the sidewalk, unredeemed. No one seems to know the diner's fate, and it is believed to have been demolished. (Courtesy of Charles H. King.)

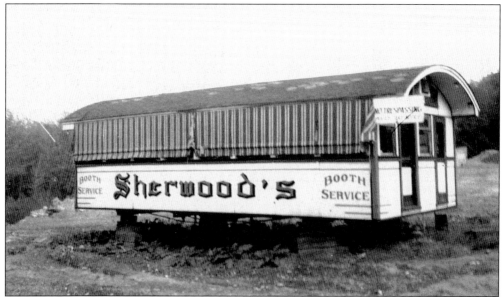

Sherwood's Diner (No. 755) was built in 1940 for Treadway L. Sherwood, who ran it in Wellington Circle, in Medford, Massachusetts. It was uprooted from that location and stored temporarily in a field outside Worcester. This snapshot was taken there *c.* 1950 before the diner was moved to Worcester and then to Route 12 in nearby Auburn, where it operated until the 1970s.

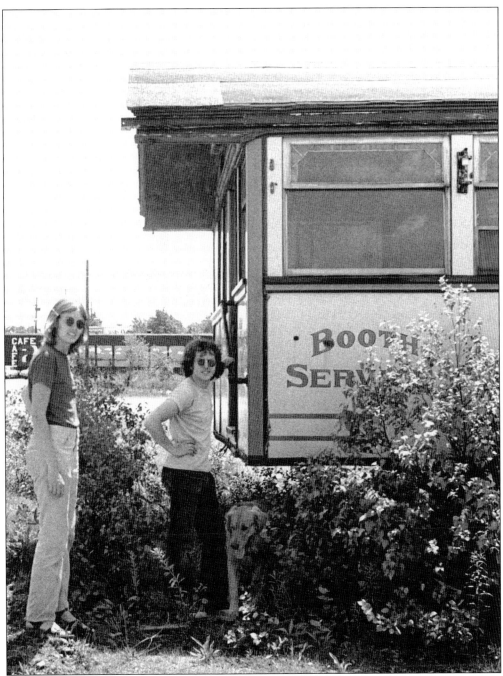

The artist John Baeder regularly cruised the highways and byways of New England with the author, hunting for diners. In 1975, they discovered Mindy's Diner (No. 747) up on blocks in a field along Route 20 near Worcester. Baeder photographed the author, his wife, Kellie, and their dog Willie, who was slinking out of the bushes after checking out the diner's undercarriage. No. 747 was originally called Porter's and was located in Somerville, Massachusetts. It was later moved from this field to Bolton, Massachusetts, where it is set up at a campground. (Courtesy of John Baeder.)

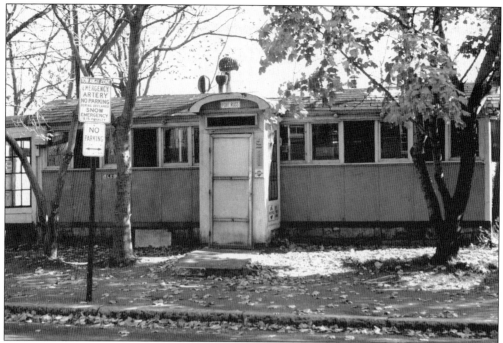

The Kitchenette Diner (No. 594) was the domain of Russell Young for 43 years. Young worked the counter along with waitress Gerry Silva (below), while cook Charlie Diamandis worked in a smaller, more ancient Worcester behind that served as the "kitchenette" for the Kitchenette. An unaltered and somewhat run-down 1930 diner, it had a twin row of stools and etched, frosted-glass windows. It is shown here in 1975 at First and Rogers Streets in Cambridge, Massachusetts. Originally the A&M Diner, it was located on Ipswich Street in Boston until 1936. (Above, courtesy of Peter Ames Richards; below, courtesy of Douglas A. Yorke Jr.)

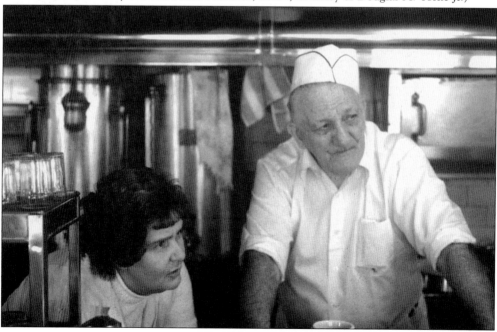

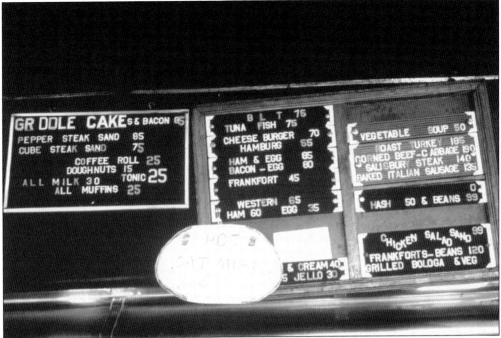

The fare from 1972 was casually displayed on menu boards above the Monel metal hood at the Kitchenette. In 1978, Russ Young lost his lease, and Tony Bosco moved the diner, initially by a team of horses. He restored it and attached it to his House Restaurant in Allston, Massachusetts. Then, in 1982, Bosco took the diner to Manhattan, where it operated briefly as the Diner on Wheels. After two subsequent moves, it was abandoned and demolished by the city.

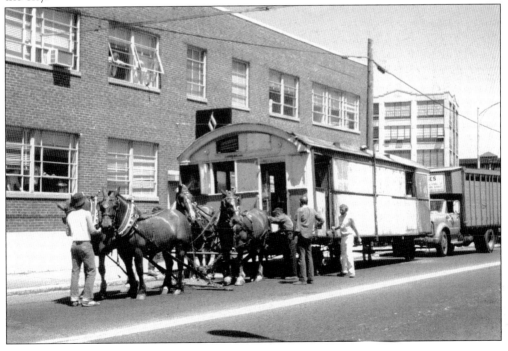

Phillips Diner (No. 792) was sent to Routes 6 and 202 in Woodbury, Connecticut, on August 1, 1946, as shown in this postcard. In 1980, John C. Chapin bought the streamliner and dismantled it. He shortened it by eight feet and reassembled it inside Bushnell Plaza in Hartford. Renamed Shenanigans, it became the focal point of an upscale restaurant. Chapin converted the backbar to a bar, removed the windows and doors, and allowed customers to sit at booths inside the diner or tables outside—all indoors. The concept did not fly, and the restaurant went belly up. (Above, courtesy of Arthur Goody.)

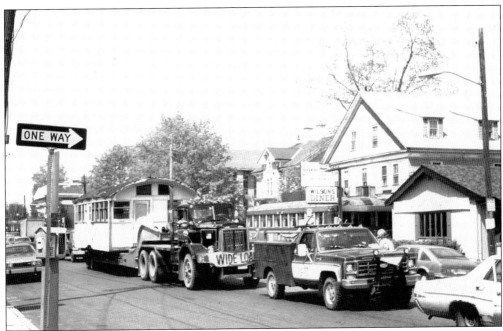

The Midway Diner was located on Route 20 in Shrewsbury, Massachusetts, through the 1970s. It was made of two diners (Nos. 636 and 666) set end-to-end, with the latter used as a dining room only. In 1981, the main diner (No. 636) was moved to Watertown, Massachusetts, by Neil Todd, who began its restoration. It is shown above as it passes by Wilson's Diner (No. 819), on Route 20 in Waltham. The diner changed hands several more times. In 1996, when the photograph below was taken, the diner was in private use in Norwich, Vermont.

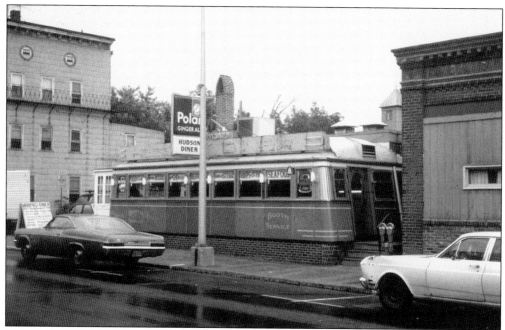

The Hudson Diner (No. 789) operated for 34 years on Main Street in Hudson, Massachusetts. The diner was built in 1946 for returning World War II veteran Clovis Lamy, who operated it in both Marlboro and Framingham before selling in 1950. After the diner was purchased by the Henry Ford Museum in 1984, the author tracked down Clovis Lamy, who not only remembered the daily specials but also supplied the original snapshot below. Lamy is leaning on the counter right behind the impressive pie display. The others are unidentified. (Below, from the Collections of The Henry Ford.)

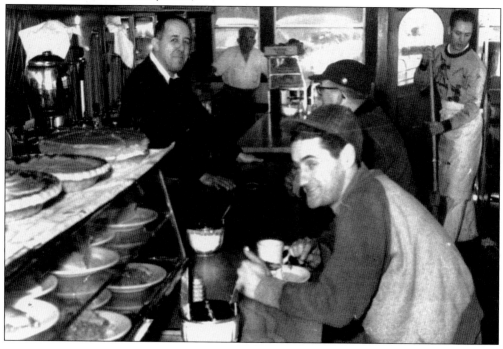

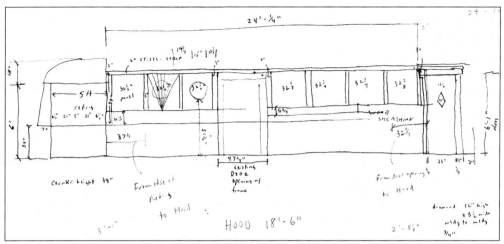

In 1950, the Worcester Lunch Car Company modernized Lamy's. The backbar was altered to place the cooking area in a separate kitchen, removing the hood and cutting a door into the back. The museum's intention was to restore the diner to its 1946 condition. The author made an on-site sketch of the changes (above). A three-year restoration ensued at the Henry Ford Museum, in Dearborn, Michigan. Clovis and Gertrude Lamy confirmed that the diner looked as good as new. Living near Worcester, they visited the plant once a week during its construction, so they really knew it inside-out. (Below, from the Collections of The Henry Ford.)

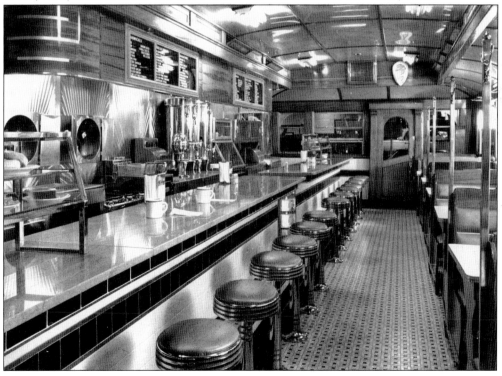

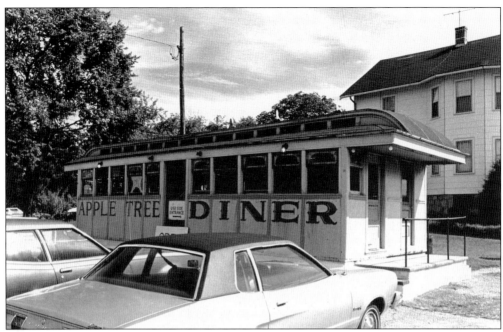

The Apple Tree Diner began as Bill's Diner (No. 641) in September 1929, when William F. Schroeder opened it in Dedham, Massachusetts, near the intersection of Washington and Court Streets. Later owned by William Cogan for 43 years, it was famous for its delicious hamburgers, known as "trophies." It remained in Dedham until 1981, outlasting the apple tree that once grew behind it. The land was sold, and the diner had to be moved. These two pictures show it in action. The photographer had finished his pie, and the dessert plate remained on the marble counter.

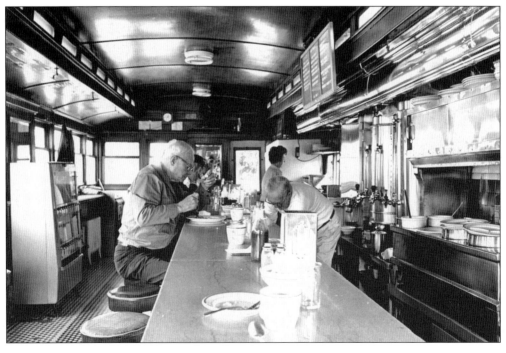

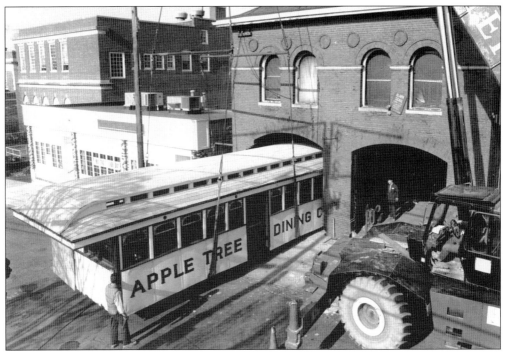

After being in storage from 1981 until 1988, the Apple Tree was purchased by Dave Waller, grandson of Jack Hines (see pages 60–61). In 1992, Waller moved the diner inside the firehouse he bought to accommodate it. The above photograph shows the mover Bryant Hill, guiding it through the opening with inches to spare. Shown below is retired sign painter David Noyd, applying some pinstriping to the Apple Tree's exterior. (Above and below, courtesy of Dave Waller.)

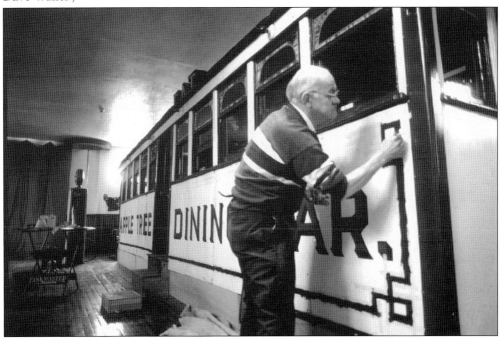

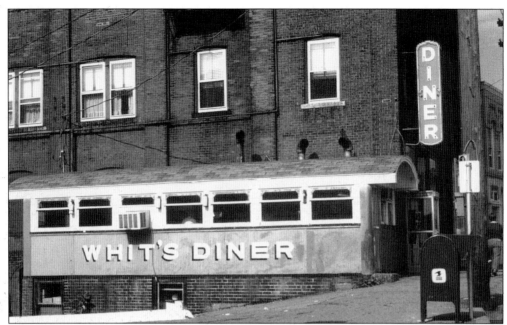

Whit's Diner (No. 783) was built for the Whitney brothers, Dick and Bob. The latter was known as Whit. It was installed on March 21, 1942, in Orange, Massachusetts, and was still in its original condition in 1973, when this photograph was taken. The diner was sold that year to Wilfred "Willie" Riddell. In 1990, Richard and Joan Lloyd bought the diner and changed the name to Lloyd's. Before moving it to Fountain Street in Framingham, Massachusetts, they restored it and commissioned a blazing red porcelain enamel façade, partially installed below, to replace the old painted sheet metal. (Above, courtesy of Peter Ames Richards.)

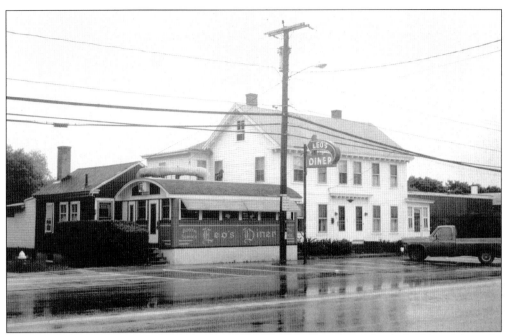

Leo and Edith Denault purchased Leo's Diner (No. 796) in 1946 for $17,000 and brought it to South Main Street in Rochester, New Hampshire. The Denaults and two succeeding generations of their family operated it there until 1985. It sat empty for three years, until diner impresario John Keith purchased it for resale. Two years later, the diner opened for breakfast and lunch business as the Harley Diner, inside the South East Harley-Davidson dealership in Cleveland, Ohio. Partially obscured by the theme-park atmosphere created by the owners, the diner and the original sign have been brought back to life.

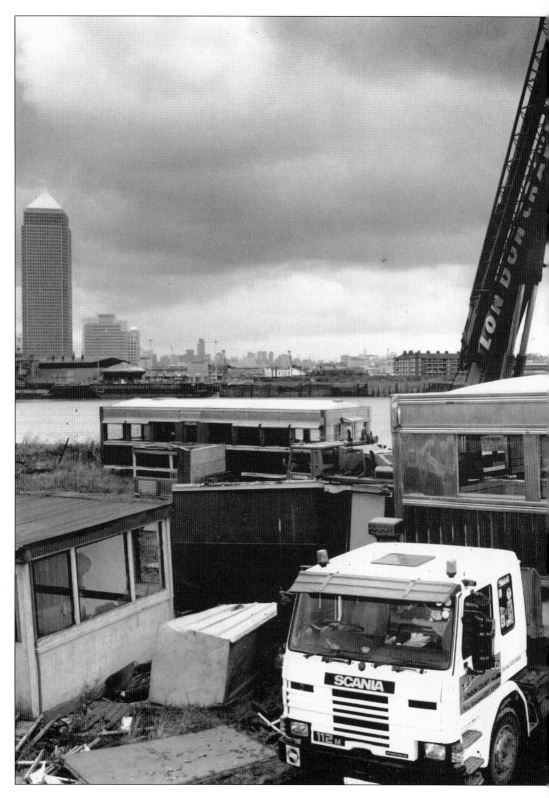

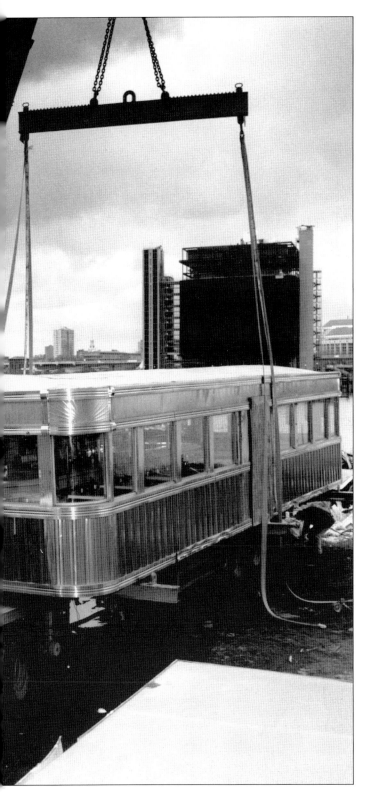

In 1992, two Worcester diners sat by the River Thames after being offloaded from a container ship that took them from New England to England. The Sea Gull Diner (No. 840), on the flatbed, and the Georgetown Diner (No. 849) were both part of a short-lived five-diner chain called Fatboy's. Diner dealer John Keith supplied the Brits with all their diners. The Sea Gull first opened in 1953 in Kittery, Maine, where it operated until the late 1980s. In December 1992, it was destroyed in a fire, after operating for only six months in Birmingham, England. The Georgetown's convoluted history took it from its original location in Georgetown, Massachusetts, where it opened in 1955, to Manchester, New Hampshire. In Manchester it was restored before moving to Los Angeles for a year. Finally it ended up in London, England, where it was set up in Spitalfields Markets, in the financial district.

INDEX TO ILLUSTRATIONS

Adams Diner, 103
Agawam Diner, 98
Alice and the Hat, 58
American Eagle Café, 20–21
Ann's Diner, 106
Apple Tree, 42–43, 122–123
Art's Filling Station, 40
Barclay's City Line, 30
Barriere, W. H., 20, 48–49
Behan's Diner, 84
Black and Gold Diner, 109
Blair's Diner, 104
Blue Moon Diner, 45
Bostonian Café, 24–25
Boulevard Diner, 46
Buckley, T. H., 12–14
Buddy's Truck Stop, 57
Buffet Lunch, 23
Cape Ann Diner, 112
Carey, Tom "the Hat," 58
Casey's Diner, 56
Central Lunch, 26
Central Square Diner, 67
Chadwick Square, 74, 98
Chair City Diner, 44
Conlin's Lunch, 88
Connolly's Diner, 110
Dan's Diner, 59
Dandy Diner, 34
Dee's Lunch Wagon, 36-37
Duprey, Philip H., 22, 62
Elm Café, 17
Ever Ready, 40–41
Federal Diner, 90
Flying Yankee, 60–61
Franklin Café, 32–33
Galligan's Café, 83
Garden Diner, 102
Gardner Diner, 44
Gemme, Charles P., 2
Georgetown, 4, 126–127
Gilley's Lunch Cart, 87

Glover Diner, 102
Harley Diner, 125
Hayes-Bickford, 111
Heald's Diner, 99
Hedlund Manufacturing
 Company, 76
Herb's Diner, 44
Hickey's Diner, 85
Hodgin's Diner, 35
Hotel Diner, 66
Hudson Diner, 120
Ingram's Diner, 64
Jimmie Evans', 75, 92
Joe's Lunch, 70
Johnnie's Diner, 65
Keene Diner, 65
Kennedy's Lunch Cart, 87
Kitchenette, 116–117
LaFleur, A. H., 30, 63,
 106–107
Lamy's Diner, 120–121
Leo's Diner, 125
Liberty Diner, 70
Lloyd's Diner, 111, 124
Lou's diner, 41, 63
Mac's Diner, 71
Mannix's Quick Lunch, 27
Mayflower Diner, 92–93
Midway Diner, 119
Mindy's Diner, 115
Miss Adams Diner, 103
Miss Worcester, 110
Monarch Diner, 105
Moran's Diner, 114
Murphy's Café, 22
Nite Owl Truck, 86, 88
Old Colony Diner, 78–79
Owl Café, 10
Palace Diner, 47
Palmer, Charles H., 11
Parks' Diner, 59, 72–73
Peerless Diner, 98

Peterboro Diner, 106–107
Phillips Diner, 118
Pilgrim Diner, 69
Pop Fleming's Diner, 80
Pullman Diner, 90
Purple Diner, 49
Quick Lunch, 16
Red Cross Wagon, 100
Rich's Diner, 68–69
Robbins Dining Car, 31
Sea Gull Diner, 126–127
Scott's Diner, 77
Shenanigans, 118
Sherwood's Diner, 114
Sidetrack Café, 38
Sterling Streamliner, 92
Stoddard, Granville, 22
Sullivan's Diner, 64
Sully's Diner, 85
Taunton Green, 82–85
Tom Thumb Diner, 47
Town Diner, 38–39
Tumble Inn Diner, 91
U-Need-A Quick Lunch, 18
United Diner, 77
Unknown Diner, 49, 104
Vermont Squire, 108
Whit's Diner, 124
White House Café, 13, 15,
 17–18, 86
Wilson's Diner, 119
Windham Grill, 75
Worcester Lunch Car
 Company catalog, 28,
 50–55
Worcester Lunch Car
 Company notebook, 67,
 94–95
Worcester Lunch Car
 Company tag, 46
Yankee Clipper, 94–97
Yankee Flyer, 71